THE HISTORY AND TECHNIQUES
OF THE GREAT MASTERS

CEZANNE

THE HISTORY AND TECHNIQUES
OF THE GREAT MASTERS

CEZANNE

Richard Kendall

CHARTWELL
BOOKS, INC.

A QUARTO BOOK

Published by Chartwell Books
A Division of Book Sales, Inc.
110 Enterprise Avenue
Secaucus, New Jersey 07094

ISBN 1-55521-493-2

This book was designed and produced by
Quarto Publishing plc
The Old Brewery, 6 Blundell Street
London N7 9BH

Project Editor Hazel Harrison
Designer Carol Perks
Picture Researcher Liz Somerville

Art Director Moira Clinch
Editorial Director Carolyn King

Typeset by Aptimage Limited
22 Clinton Place, Seaford, East Sussex BN25 1NP
Manufactured in Hong Kong by Regent
Publishing Services Limited
Printed in Hong Kong by Leefung-Asco
Printers Ltd

CONTENTS

THE PAINTINGS

INTRODUCTION

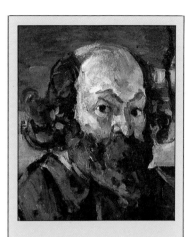

PAUL CEZANNE
Self-portrait (detail)
c 1872, Musée d'Orsay, Paris

Paul Cézanne's early years appear at first sight to conform almost too easily to the popular mythology of the struggling and misunderstood painter. He fought against the conventional aspirations of his family, escaped to join the bohemian artistic circles of Paris, suffered the indignity of rejection from public exhibitions, and worked doggedly at his painting for many years before tasting any kind of success. There is, however, evidence that Cézanne cultivated this view of himself, flaunting his long hair and abrasive manners in polite society and deliberately submitting violent or erotic pictures to exhibition juries. He could be abrupt and temperamental even with close friends, was savage in his denunciation of critics and cultural bureaucrats, and his commitment to his own art was never less than fierce. There have been few artists as dedicated as Cézanne, but also few whose formative years were so problematic and unexpected.

Early years
Paul Cézanne was born in 1839, and his adolescence and early manhood appear to have been dominated by his father, Louis-Auguste Cézanne, a self-made business-man and banker from Aix-en-Provence in southern France. Paul showed considerable aptitude at school, and was destined to follow in his father's footsteps. As a schoolboy, however, he preferred to roam the country-side with his small band of close friends (one of whom was Emile Zola, the future novelist) talking of art and reading aloud their own and others' poetry. At the age of nineteen, Cézanne started to study at the local drawing academy, where he learned to produce highly disci-plined, if rather conventional, studies from the nude male model. Braving his father's wrath, he announced that he wanted to leave Aix for Paris and embark on a career as an artist.

Cézanne senior was accustomed to getting his own way, but on this occasion he met his match. In 1861, after bitter arguments, Paul was provided with a meager allowance and allowed to travel to the capital. Despite the pleasure of meeting up again with his friend Zola, who had preceded him to Paris, the young man experienced a number of set-backs, and more than once had to return to his family home. But the decisive break had been made, and throughout the 1860s, Cézanne worked at his voca-tion, drawing from models, studying the masters of the past in the Louvre and gradually making the acquaintance of other unknown young artists, such as Camille Pissarro and Armand Guillaumin. His growing self-confidence is reflected in his few surviving letters from this period and in the record of his several submissions to the official Salon.

The character of the pictures he sent in, several of which survive, helps both to explain their rejection by the Salon juries and to summarize something of the young artist's ambitions. The large portrait of 1870 *Achille Emperaire* (see page 19), was not only rejected by the jury of that year, but also lampooned in a contem-porary illustration. Emperaire was a lifelong friend of Cézanne's, a fellow painter from Aix, who suffered from a serious condition that left his legs under-developed and feeble. As in his portrait of his father shown opposite, Cézanne has presented Emperaire with extraordinary boldness, almost defying the spectator to turn away from the unlovely creature who completely dominates the large canvas. Another picture from the same period, *The Murder*, shows Cézanne at his most defiant, wilfully distorting the limbs of his figures, and bending the con-tours of the landscape to accommodate the ferocity of the scene. The paint is thickly applied, the implicit emotion raw and impulsive, as if the artist were giving direct expression to his own passionate temperament.

The idea that an artist's principal function is to express his temperament through his chosen medium seems to have been an article of faith for both Cézanne and Zola. Zola's definition of art as "nature seen through

PAUL CEZANNE
Portrait of Louis-Auguste Cézanne, Father of the Artist
c 1862, National Gallery, London

Originally painted directly onto the wall of the family home by the twenty-three-year-old artist, this large picture was later transferred to canvas. The rough handling of the paint and the awkward positioning of the figure say a lot about the young Cézanne's fierce independence and probably as much about his uneasy relationship with his father.

a temperament" emphasizes the uniqueness of the individual's own sensibility and, by implication, the possibility that the most extreme traits of personality can find expression in a novel or a painting. His own books had begun to explore the psychological basis of sexual passion and human violence, often in ways that seem to parallel Cézanne's tormented early pictures. At the same time, both artists knew that such unconventional subject matter could not be expressed within the polite conventions of the day, and each sought for a more authentic, pared-down language for their art.

New directions
Another decisive influence on Cézanne's early career was his contact with the group of artists who were later to exhibit under the name of the Impressionists. A letter of 1865 shows that he had already made the acquaintance of Pissarro, and subsequent letters and paintings

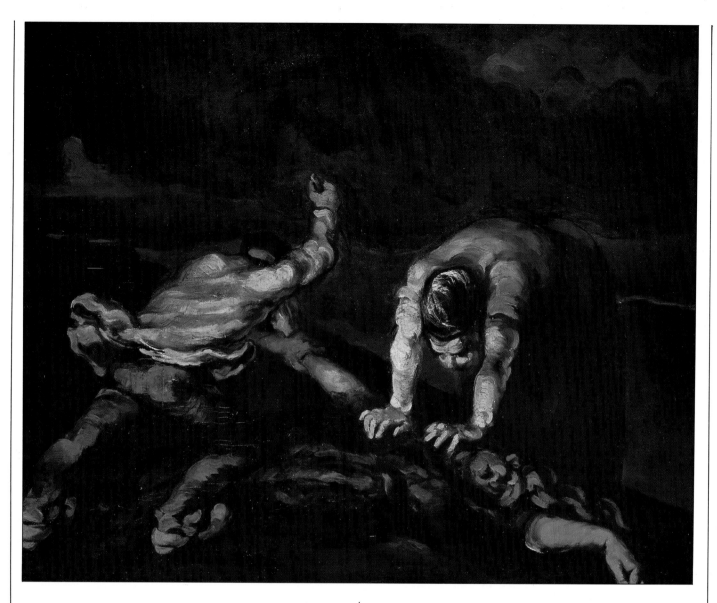

PAUL CÉZANNE
The Murder
1867-68, Walker Art Gallery,
Liverpool

Scenes of lust, violence and
fantasy are common in the
first decade of Cézanne's
career, and offer a complete

contrast to the apparently
serene subject matter of his
later years. *The Murder* has
parallels in the popular
imagery and literature of the
day, and appears to be part of
an attempt by the artist to
express extremes of emotion
as directly as possible.

show that the two artists worked together in the country-side, often in front of the same subject. Pissarro was a man of almost saintly character — Cézanne described him as "that humble, colossal Pissarro" — and his patient example and knowledgeable advice affected his younger colleague deeply. For some time Pissarro had devoted himself to outdoor subjects, to the hillsides and farms of his home-town of Pontoise, near Paris. In his company, Cézanne learned to direct his own deeply felt sensations of nature into rich paint textures and strongly conceived compositions, lightening his palette and intensifying his colors in response to his open-air subjects. As if in tribute to Pissarro, two of Cézanne's three submissions to the first Impressionist exhibition of 1874 were landscapes, both influenced by his friend in subject matter and handling, but both recognizably the work of a changed and confident young painter.

Other events had also helped to propel Cézanne's career in new directions. In about 1870 he had begun living with his former model, the twenty-year-old Hortense Fiquet. Two years later she gave birth to a son, also christened Paul, though great care was taken to conceal both the child and the relationship with Hortense from Cézanne's family in Aix. Cézanne appears to have found some fulfilment and stability in his new way of life, but it is a mark of the continuing influence of his father, and perhaps Cézanne's fears for his allowance, that it took more than ten years for him to admit to the existence of his mistress and son.

As a personality, Cézanne continued to shock his con-

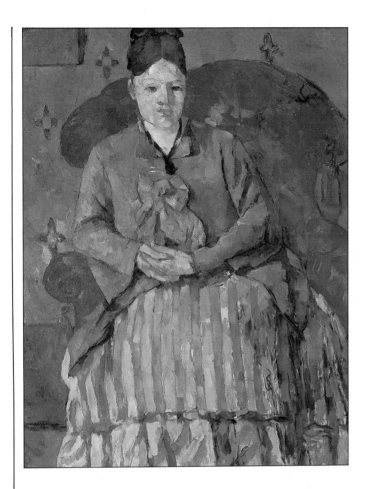

PAUL CEZANNE
Madame Cézanne in a Red Armchair
c 1877, Museum of Fine Arts, Boston

Hortense Fiquet had not yet married Cézanne at the time of this painting, though she had borne their son, Paul, about five years earlier. She had worked as an artist's model in her teens and sat patiently for Cézanne on many occasions. Her dour expression may reflect her boredom at the subsequent hours of immobility.

temporaries by his displays of rough, provincial manners and sudden outbursts of temper, both growing from a fierce determination to remain independent and stay true to what he saw as his "temperament." Cézanne's view of himself, as shown in his many self-portraits, is of an intense, rather swarthy individual whose prematurely balding head enhances the severity of an already stern countenance. His relationship with Hortense was never an easy one and they were to live apart for much of the time, but she seems to have been a compliant model, and is the subject of some of Cézanne's grandest and most subtle portraits. In spite of his attempts to conceal his son's existence, Cézanne was inordinately fond of the

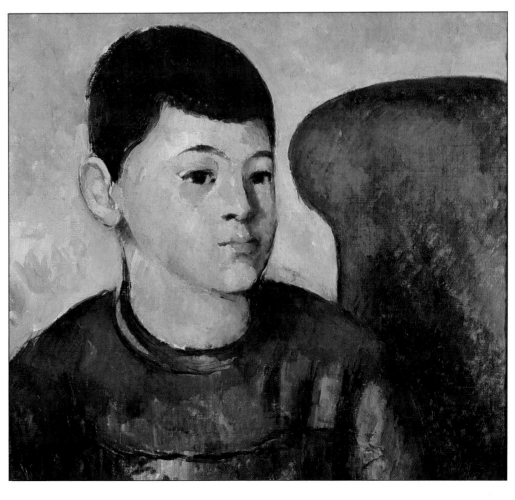

PAUL CEZANNE
Portrait of the Artist's Son
c 1884, Musée de l'Orangerie, Paris

Paul was twelve or thirteen years old when he posed for this portrait, one of more than a dozen painted by his father. Cézanne was always indulgent towards his son, overlooking his youthful misbehavior and allowing him to drift into manhood without training or employment.

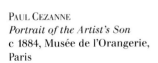

young Paul, and there are numerous tender drawings and painted studies of the boy, recording his transition from childhood to adolescence.

The landscape painter

Important though portraiture was to Cézanne, both as an expression of his private world and as a link with a past tradition, the subject that increasingly commanded his attention was landscape. In his mature years, landscapes dominated his output, and it is above all the mountainsides and woodland of his native Provence that reappear in his work. Cézanne was always conscious of his Provencal origins, and his choice of local subject matter was as much a matter of pride as one of convenience. Certain features of the locality, such as the pine trees and reddish-ocher rocks, had a special significance for him, while the towering mountain to the east of Aix, Mont Sainte-Victoire (see page 47), seemed to embody the mysterious, pagan essence of the region. Although he continued to spend time in Paris and elsewhere, and despite financial worries and family disputes, Cézanne returned more and more frequently to Provence to paint the landscapes he had loved since childhood.

As his commitment to the landscape grew, the distinctiveness of his technique became more apparent. During the 1870s, his struggle with the sense of exhilaration he felt in the presence of nature combined with the

CAMILLE PISSARRO
The Edge of the Village
1872, Musée d'Orsay, Paris

Painted at a time when Cézanne was working closely with Pissarro, this canvas summarizes many of the characteristics that he admired in the older man's work. A simple country scene, frontally encountered and lit by clear sunlight, is constructed from bold brushstrokes and a dramatic interplay of horizontal and vertical compositional elements.

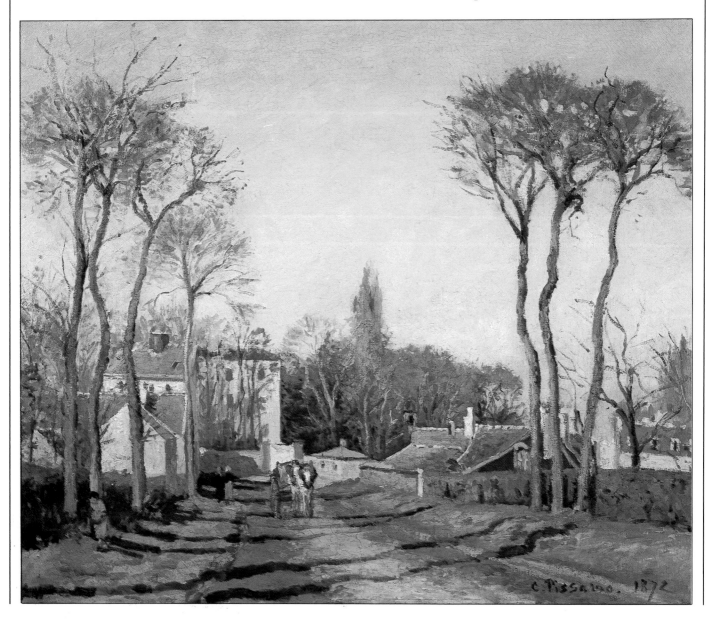

PAUL CEZANNE
Château de Medan
c 1880, Burrell Collection,
Glasgow

Cézanne made a number of
visits to stay with his friend

Emile Zola in his grand house
at Medan, before Zola's
ostentatious prosperity and
declining sympathy for the
painter's achievement
eventually led to a complete
breakdown in their friendship.

demands of painting directly from the chosen "motif," or subject, resulted in some densely worked but increasingly distinctive canvases. Thick flourishes of pigment gave way to organized, regimented sequences of brushstrokes, creating subtle rhythms across the picture surface, echoing the principal elements of the composition. In these works, the dominating principle is a deep sense of deliberation, against which each tree, each rock and each individual leaf is judged. Color, shape, spatial intervals and surface texture all breathe life into the chosen subject, and everything extraneous to the composition is boldly eliminated. This procedural rigor has sometimes been seen as coldness, but nothing could be further from the truth: it is rather that the intensity of Cézanne's delight in "the manifold spectacle of nature," as he once described it, could only be contained within the most resilient of structures.

The landscape and the climate of Provence were ideally suited to an artist who worked out of doors. Cézanne insisted on the need for direct and continuous contact with his subject, and would stride out into the countryside, easel and canvases on his back, and walk for several miles to one or other of his favorite sites, such as the railway viaduct near Aix, the quarry at nearby Bibémus (see page 58) or one of the views of Sainte-Victoire (see page 47). It is noticeable that most of his canvases depict bright or lightly overcast weather. Because he needed time to build up his carefully structured compositions, the steady light of the Mediter-

ranean appealed to him more than the transient effects of light and the seasonal extremes of snow and rain that so attracted his contemporaries, such as Claude Monet. Contemporary accounts describe how Cézanne would gaze intently at his chosen scene, weighing up the evidence of his eyes for several minutes before darting at his canvas with a rapid movement of the brush. At times his patience and his sense of his own achievement deserted him and he would slash the canvas with a knife or hurl it into the bushes.

Cézanne's painstaking approach to his art was rarely compromised by the demands of the market-place, since

he was supported by the allowance from his father and by sporadic contributions from the increasingly successful Zola. One or two brave collectors and fellow artists bought his canvases — though at very modest prices — but his decision to stop exhibiting with the Impressionists after the third Impressionist Exhibition of 1877 ensured that his work was entirely unknown to the general public. His life revolved around his painting, and both his journeys to and from Paris and his periods of residence in towns near Aix, such as L'Estaque and Gardanne, were part of a restless relationship with his "motifs."

As Cézanne approached the age of fifty, the modest pattern of his life and his erratic cohabitations with Hortense and young Paul seemed as settled as at any point in his early life. But in 1886, three events occurred that were to affect him profoundly and completely alter his circumstances. Early in the year, Zola published his novel *l'Oeuvre* ("The Masterpiece"), the story of a failed painter who was clearly based on Cézanne. The two men's friendship had already cooled considerably, but Cézanne was deeply hurt, and resolved to sever all connections with his childhood friend. Shortly afterwards,

GUSTAVE COURBET
Still life with Apples and Pomegranate
1871, National Gallery, London

As a young man, Cézanne had been inspired by the vigorous independence of Courbet's personality and also by the flourishing application of

paint in some of his pictures. Though he was later to belittle this influence, Courbet's ability to capture the drama of everyday objects unpretentiously arranged must have contributed something to Cézanne's own development of the still life.

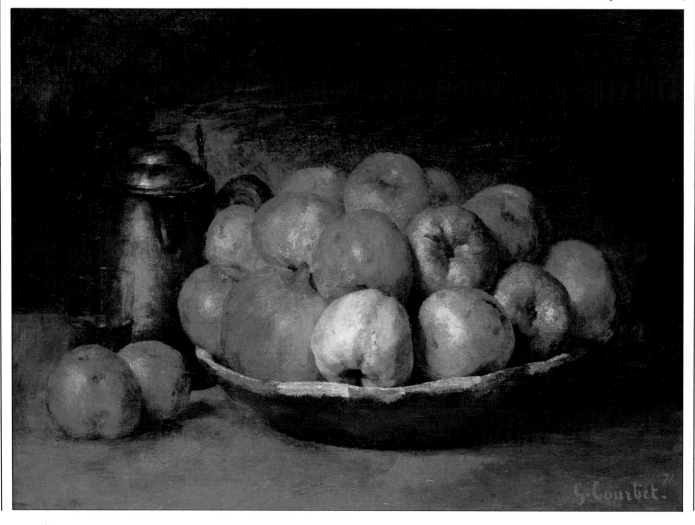

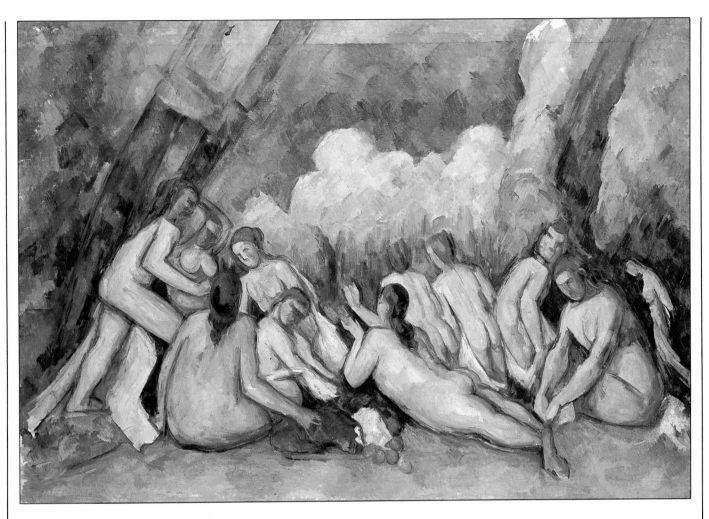

Cézanne publicly married Hortense in a church at Aix, thus legitimizing his son Paul and bringing to an end the years of deceit and procrastination. Within months of the ceremony, Cézanne's eighty-eight-year-old father died, leaving his substantial estate to his son, and so ensuring him a steady income for the remaining thirty years of his life. Released from the dominance of his parents, reconciled with his family and with the demands of conventional propriety, Cézanne was now free to follow his vocation and to live the life he chose.

Still life and the nude
In spite of his dedication to landscape and portraiture, two other subjects continued to preoccupy Cézanne throughout his mature years. The best known is still life, a *genre* with which his name will always be associated. Gathering together a few simple household objects, such as wine bottles, plates and water jugs, and interspersing them with the common fruit, vegetables and flowers of Provence, he constructed magical worlds of sensation that are amongst his most admired achievements. He would spend hours arranging these little groups, and days or even weeks painting them, rendering each of the subtle relationships of form and color that revealed

PAUL CÉZANNE
Bathers
c 1905, National Gallery,
London

Still in his studio at the time of his death, and probably unfinished, this large canvas is one of a monumental group of three that Cézanne worked on

in the early 20th century. The subject is improbable, the figures vacant and anatomically brutalized, but the composition achieves an extraordinary frieze-like gravity that reminds us of Cézanne's admiration for classical art.

themselves to his analytical eye. Conscious, as always, of tradition, Cézanne saw himself as a descendant of both the 18th-century still life painter Jean-Baptiste Chardin and of Gustave Courbet, one of the heroes of his youth. But in his hands still-life painting was transformed, the previously humble *genre* becoming one of the great modern vehicles of artistic innovation.

The idea Cézanne had of himself as part of a continuing tradition in Western art is particularly evident in the other recurring subject of his career, the nude. From his earliest years he had drawn the human figure, from models, from paintings and sculptures, and from his imagination. He returned time after time to certain

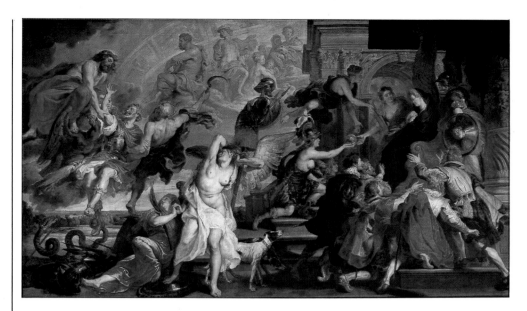

PETER PAUL RUBENS
The Apotheosis of Henri IV
c 1621, Louvre, Paris

When asked to nominate his favorite painter, Cézanne chose the Flemish Baroque master, Rubens. On a number of occasions he studied and copied Rubens's pictures in the Louvre, and the central figure with the raised elbow in this *Apotheosis* occurs in a number of guises in his own compositions.

poses based on the works of Rubens, Michelangelo and Poussin, and even claimed a lifelong ambition to create a large composition of nudes, such as those of Poussin, but to paint it in the open air, an ambition he was never able to fulfil. For a number of reasons he appears to have had trouble hiring models, and in his mature years he worked almost exclusively from earlier drawings or from memory. The subject, however, lost none of its significance, and in the early years of the 20th century he embarked upon a group of huge, spirited, almost visionary compositions of female nudes, their bodies subordinated to the demands of pictorial orchestration.

The "grand old man" of painting

Cézanne's reputation among a small group of artists, critics and collectors had been quietly growing for some time, and in 1895, when he was fifty-six, the insularity of his existence was effectively ended by the first retrospective exhibition of his work, held at the Paris gallery of the dealer Ambroise Vollard. He was now able to enjoy an unexpected, belated celebrity, and a steady stream of writers and fellow painters began to make the pilgrimage to Aix. Although still defensive of his working routine, he could be surprisingly warm towards younger artists, and explained to them, sometimes in letters which survive today, a number of his views on art. He insisted on nature as his primary inspiration and on the need to recognize the intensity of visual experience. Art was not a copy of nature, but a "parallel" to it, and even in his last years he recorded his continuing frustration as he tried to "realize" his motif.

In spite of deteriorating health, Cézanne persisted in his habitual and obsessive routines until his death in 1906. Hardly leaving the Aix area, he still preferred to work in the open air from his favorite vantage points,

often returning to subjects he had painted dozens of times before. His sense of the complexity of art, of its intimate but paradoxical relationship to the perceived world, had deepened, and he continued to experiment with new techniques and ideas until his last months. At times he would strip down the shapes of his chosen subject to a few spare lines and forms, like the ellipses of a bowl of fruit or the parallels of branches and tree trunks, while at others he would build up dense and subtle reverberations of color, texture and surface incident. In his late paintings, the language of his art announces itself with increasing clarity, insisting on its separateness from observed nature while moving closer to the "vibrating sensations" of the scene that he himself described.

Among the young artists who discovered Cézanne's painting in the years before his death were some of the major figures of the Parisian avant-garde, notably Matisse, Braque and Picasso. A series of exhibitions of the elderly master's work was held in Paris at the turn of the century, and his influence can be felt in the younger artists' choice of subjects, color harmonies and stylistic devices. Georges Braque went as far as to travel to Provence to paint in front of some of Cézanne's subjects, while Picasso was principally attracted to the great bather pictures. His admiration for Cézanne is openly acknowledged in his *Demoiselles d'Avignon* of 1907, one of the cornerstones of Cubism and of early 20th-century art. Although Cézanne did not live to see these developments — and might not have approved of them if he had — he was clearly gratified by the attentions of the younger generation. Sensing the significance of his work for the future of painting, he declared at the end of his life that, "I am the primitive of a new art."

CEZANNE'S PAINTING METHODS

The House of the Hanged Man is one of Cézanne's most densely worked canvases. The encrusted paint seen in this detail is suggestive of the building's weathered texture.

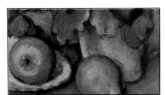

This detail from *Still Life with Apples and Pears* shows the marvelous variety of different colors Cézanne used for each area of a painting.

In Cézanne's mature works, such as *The Red Rock*, each brushstroke is carefully planned. One incorrectly judged color or tone would destroy the harmony.

Although Cézanne's name is often linked with the Impressionists, and he exhibited with the group in the first three Impressionist Exhibitions, his preoccupations and technique were very different. After painting side by side with Pissarro in the 1870s, he became deeply committed to working outdoors, directly from his "motif," or subject, but unlike the Impressionists, who were concerned with immediate and transient effects, and painted rapidly, Cézanne was a slow and laborious worker, and his studies from nature were sustained over a period of time. Because he often returned to the same canvas months or even years later, the relatively stable light of the south of France suited him, as did still life painting, which gave him total control over the lighting and arrangement of his subject matter. All the compositions of his mature years, whether landscapes, still lifes or portraits, are carefully thought out. His fastidious concern for finding the exact tone or color for each brushstroke reflects his desire to construct an overall harmony of color, tone and surface pattern in which no note was out of tune — a painterly equivalent to the harmony seen in nature. For his oil paintings, he used a relatively limited palette, usually working on a pale cream ground which he left uncovered or lightly covered in places to read as a color in its own right. His characteristic broad brushstrokes are used not only to express volume and solidity but also to shape the composition, his most quoted advice, to "see nature in terms of the cone, the cylinder and the sphere" being matched by an equally strong sense of the structure of the painting.

Mountains in Provence was painted on primed paper, the equivalent to today's oil-sketching paper. It was later mounted on canvas. The choice of support was unusual, as Cézanne normally worked on canvas; he may have chosen it for reasons of portability, as the painting, one of his sustained studies from nature, was clearly not regarded as a sketch. His palette probably consisted of the colors shown below.

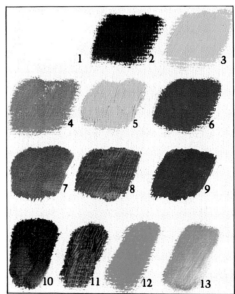

1 zinc white; 2 black; 3 chrome yellow; 4 yellow ocher; 5 Naples yellow;
6, 7 red earth or vermilion;
8 cobalt blue; 9 ultramarine; 10 Prussian blue;
11 viridian; 12 emerald green; 13 chrome green

CHRONOLOGY OF CEZANNE'S LIFE

1839 January 19: Paul Cézanne born in Aix-en-Provence.

1849-52 Attends Ecole St Joseph in Aix-en-Provence.

1852-58 Attends Collège Bourbon in Aix. Beginning of friendship with Emile Zola.

1858-59 Works at drawing academy at Aix.

1859 Father acquires house, Jas de Bouffan.

1861 First residence in Paris.

1863 Exhibits at the Salon des Refusés.

1870 Stays at L'Estaque with his mistress Hortense Fiquet. Submits *Portrait of Achille Emperaire* to Salon, but it is rejected.

1872 Birth of Cézanne's son, Paul. Lives near Pissarro at Pontoise. The two artists work together.

1873 Moves to Auvers-sur-Oise, meets Dr Gachet, who later befriended Van Gogh.

1874 Cézanne shows three pictures in the first Impressionist Exhibition.

1875-86 Lives intermittently at Aix, L'Estaque, Gardanne, Pontoise, Paris and elsewhere. Several visits to Zola at Medan.

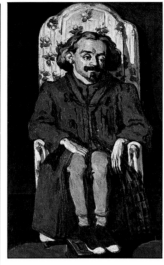

Portrait of Achille Emperaire

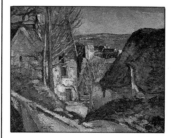

The House of the Hanged Man

1877 Exhibits sixteen pictures at the third Impressionist Exhibition.

1886 Cézanne marries Hortense Fiquet, mother of his son Paul. Louis-Auguste Cézanne, the artist's father, dies, leaving him a substantial legacy.

1889 Renoir visits Cézanne in Provence.

1890 Invited to exhibit in Brussels. Travels with his family for a holiday in Switzerland.

1894 Visits Monet at Giverny.

1895 First one-man show at Vollard's gallery in Paris.

1896-99 Residence in Paris and Aix.

1897 Death of Cézanne's mother.

1899 Sells Jas de Bouffan to settle father's estate. Rents apartment in Aix. Paints portrait of Vollard.

1901 Plans the building of a new studio overlooking Aix.

1904 Exhibitions of Cézanne's work in Brussels and Paris.

1906 Exhibits in Paris at the Salon d'Automne. October 15: collapses while painting outdoors, and has to be carried home. Dies on October 22, aged sixty-seven. Buried in Aix-en-Provence.

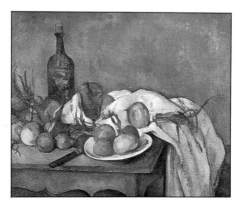

Still Life with Onions

THE PAINTINGS

PORTRAIT OF ACHILLE EMPERAIRE

c1868-70
78¾×48in/200×122cm
Oil on canvas
Musée d'Orsay, Paris

One of the largest and most haunting of Cézanne's early canvases, this picture was important to him both as a personal document and as a milestone in his artistic development. It is an ambitious, fully resolved and large-scale work, testifying to the emergence of a confident and aspiring young artist.

Achille Emperaire, a painter friend of Cézanne's from his home town of Aix-en-Provence, was about a decade older, but a curious affinity united them from their earliest meetings at the drawing academy in Aix. Little is known about Emperaire, but his few surviving paintings and drawings are small, intense and often erotic studies of human figures which clearly had a considerable influence on Cézanne. On a number of occasions in later life, Cézanne became fiercely defensive about his friend, contrasting his seriousness and integrity with the pretentiousness of contemporary art. He even wrote to Zola in Paris in 1878, pleading with him to find a job for Emperaire, who seems to have been in continual financial difficulties throughout his life.

In contrast to many of Cézanne's large pictures begun in the late 1860s, the portrait of Emperaire is a study of a real subject rather than one drawn from the artist's imagination, and its great strength derives from the abrupt confrontation with an image so familiar and of such personal significance. The figure is centrally placed, the chair parallel to the picture-plane, the body symmetrical except for minor inflections of head, hand and feet. A brilliant source of light illuminates both sitter and chair (the same chair appears in a number of pictures of Cézanne's home), and the primitive lettering added at the top of the canvas suggests a heraldic, almost regal image of authority. Emperaire's hair and beard, more 18th- than 19th-century in style,

contribute to this effect, suggesting the enthronement of a neglected genius — or possibly a pun on the sitter's imperial-sounding name.

Several preparatory drawings for the picture survive, notably for the monumental head of the subject. These have something of the elegance and refinement of Rubens, an artist Cézanne admired deeply, and they give an idea of the complex stylistic maneuverings that Cézanne was involved in at this stage in his career. His early life drawings show that he could produce conventional, disciplined studies when required, but much of his art from the 1860s shows a rejection of contemporary style and a search for a more challenging, personal way of working. The thick, textured paint of this portrait and the boldly outlined contours, as well as the aggressive directness of the image, are all part of a public assertion of the artist's uncompromising temperament.

Not surprisingly, when Cézanne submitted the portrait to the Government-sponsored annual Salon of 1870, along with a picture of a reclining nude (subsequently lost), both pictures were rejected. The painting provoked a largely satirical response amongst those present at the judging, and the cartoonist Stock produced a caricature of a monstrous, bearded Cézanne with his grotesque submissions. Stock also claimed to have interviewed Cézanne, and drawn from him such views as "I paint how I see and how I feel" and "I have the courage of my convictions, and he who laughs last, laughs loudest." The portrait of Achille Emperaire was one of the last group of pictures which Cézanne intended as gestures towards an uncomprehending establishment, and it is the majestic and deeply felt realism of this study that points the way to the future.

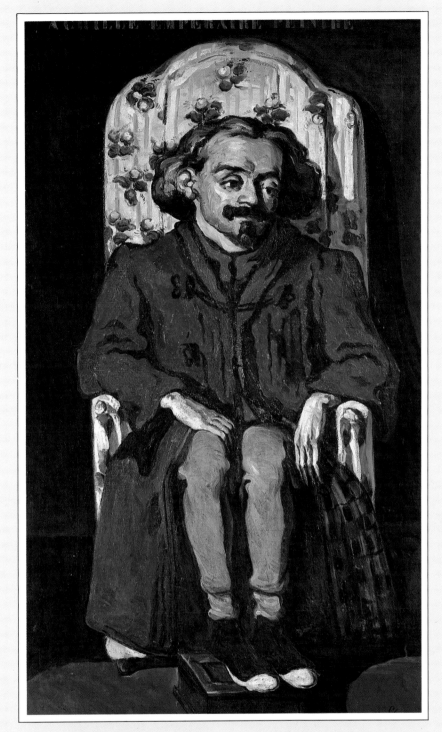

The surface of the canvas is thickly encrusted with paint over much of its surface, and many areas, such as the face and hands, show evidence of considerable over-painting. Some of Cézanne's pictures from this period emerged only after a long struggle, both with the medium and with the demands of the subject, but the artist was always capable of displays of great fluency, such as the painting of the floral chairback.

1

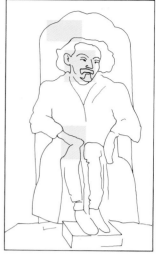

1 The patterned fabric of this upright and rather uncomfortable-looking chair appears in several of Cézanne's domestic portraits, most famously in an identically sized study of his own father begun two or three years earlier. In this picture the boldly depicted floral motif and the heavily impasted paint help to draw attention to the flatness and frontality of the painting, as do the stencilled lettering and the symmetrical pose.

2 The thick crust of oil paint almost appears to be out of control in some areas of the picture, but in Emperaire's head the vigorous black outlining and modeling give it strength and purpose. It is noticeable how a rhythmic flow directs the movement of the brushstrokes, following the contours of chin, bone-structure and facial features.

3 *Actual size detail* Emperaire suffered from a debilitating condition that left his legs and body underdeveloped, thus making his head appear abnormally large. Cézanne has chosen to celebrate his friend by drawing particular attention to those parts of him that were most deformed, thrusting the legs forward and emphasizing the pale hands by contrast with the dark background. The slender, limp fingers seem quite pitiful against the rest of this vigorously constructed painting.

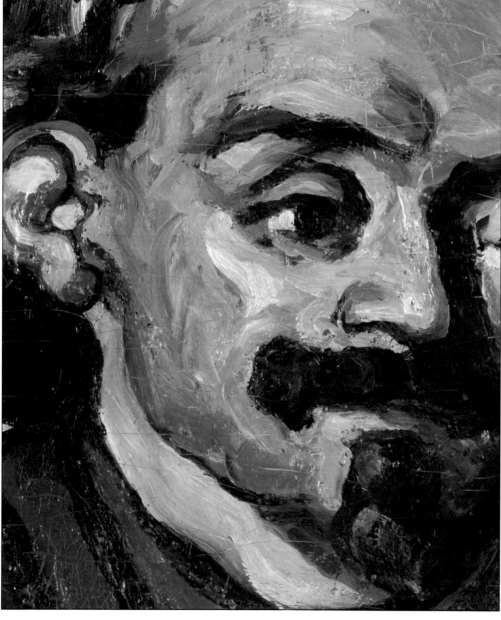

2

3 *Actual size detail*

SELF-PORTRAIT

c1872

$25\frac{1}{4} \times 20\frac{1}{2}$in/$64 \times 52$cm

Oil on canvas

Musée d'Orsay, Paris

It is hard to believe that Cézanne was only thirty-three years old when he painted this picture. The description of his stocky torso, dramatically balding cranium and unruly sidelocks all suggest either a ruthless honesty in his presentation of himself or an almost theatrical attempt to shock the viewer. Cézanne was either careless about his appearance or deliberately cultivated a wild bohemian look, and it is said that children threw stones at him in the street.

At the time this portrait was painted, Cézanne was going through one of the most challenging phases of his career. Behind him lay his struggle to find independence from his family and his desperate attempts to assert himself as an artist in a society where, as he saw it, only polished technique and superficial display were admired. His early pictures of gruesome or fantastical encounters between imaginary human beings had inevitably suffered rejection, but slowly he had been turning to other ideas and other possibilities for his future. Under the influence of Pissarro, Guillaumin and other members of the emerging Impressionist group, he was experimenting with a more direct approach to painting, based on firsthand observation and a fresh encounter with the notion of Realism. Painting outdoors, side-by-side with his friends, he re-assessed the rich textures, vivid colors and infinitely varied shapes that he saw in nature, bringing these new discoveries back into the portraits and still lifes developed in his studio.

His personal circumstances had also changed; this self-portrait coincides with the year in which his only son, Paul, was born out of wedlock to his mistress Hortense Fiquet. It is more than likely that the exceptional gravity of the portrait marks a moment of self-assessment, and we see the artist surveying himself in the role of father and breadwinner to his small family. The gaze is implacable, the eyes black and severe, the pose little short of truculent. Little is known of the private relations of Cézanne with his immediate family, but it is worth reflecting that this formidable man had attracted the attentions of the pretty and fashion-conscious Hortense, even though she was more than ten years his junior, and that he was to become an affectionate father.

The technique of the *Self-portrait* vividly illustrates the transitional stage of Cézanne's painting. The heavy nature of the paint-surface and the extensive use of black both belong to the previous decade, and were rarely to be seen again in his mature work. Even the gestural flourishes of the brush, almost scribbled over thickly painted under-layers or smeared across still-wet color, suggest an impatience that was soon to be mastered. But the handling of the face suggests analysis rather than intuition: the subtle shifts of tone and color are carefully scrutinized, and the brushwork organized — albeit in a rudimentary manner — to echo the structure of the face. The fresh touches of color, the greens in the shadow and the pinks in eyelid and nostril, show that Cézanne's discoveries while painting in the open air were now beginning to bear fruit in his studio works. The face is alive with suggestive nuance and tense energy, the fluid paint evoking hazardous decisions and bold improvisation.

As if to summarize his own change of direction, Cézanne has posed himself in front of a canvas by his friend Armand Guillaumin, a picture that was probably included in the first Impressionist Exhibition in 1874. It has a double significance: not only is it a landscape, a subject that Cézanne was increasingly to adopt during this decade, but it was also associated with that radical group of young artists who were soon to present a new kind of art to the Parisian public.

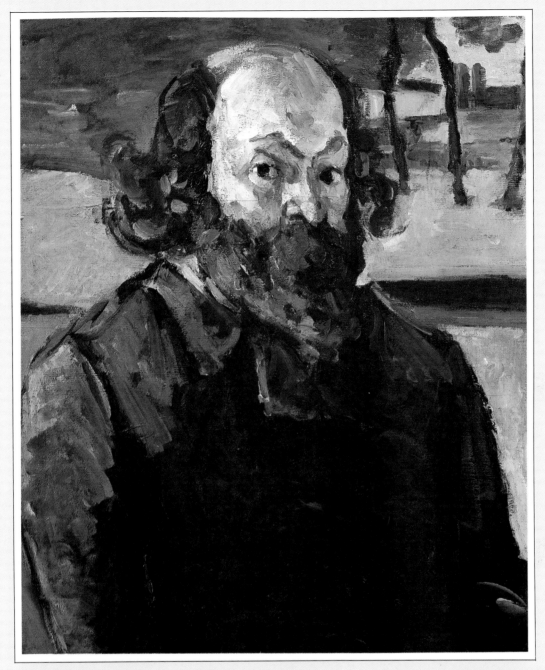

Cézanne painted more than twenty self-portraits in the course of his career, though this is perhaps his most disconcerting. In later examples he adopts a more distant expression, and emphasizes the subtle play of light and color on his own features, but here he is defiant. Inspired perhaps by the dramatic self-scrutiny of Rembrandt or the posturing of Courbet, he has placed his face in a central pool of light and surrounded it with a riot of unkempt hair. The result is authoritative, messianic and entrancing. The penetrating gaze of the eye reminds us of Monet's description of Cézanne as "Only an eye, but my God, what an eye!" The act of looking and analyzing had by this time become increasingly central to his art, and in this portrait he has given vivid form to the center of his own visual world through the rich manipulation of pigment and the sharp juxtaposition of colors and tones.

1 The painting by Guillaumin that Cézanne has placed behind his head is in reality a detailed study of the embankment of the Seine, complete with figures, boats and a distant Notre-Dame. In order to concentrate attention on his own features, Cézanne has shown it in simplified form. The painting, which is reversed by the mirror used in the self-portrait, is here reduced to a few blocks of color, with Notre-Dame merely suggested by two vertical brushmarks.

2 *Actual size detail* In places the weave of the canvas can be glimpsed beneath the paint, but most of the face has been built up quite heavily with thick, undiluted paint. Much of it has been applied while earlier brushmarks were still wet, allowing adjacent colors to blend into each other but retaining a few streaks of pure, unmixed hue.

1

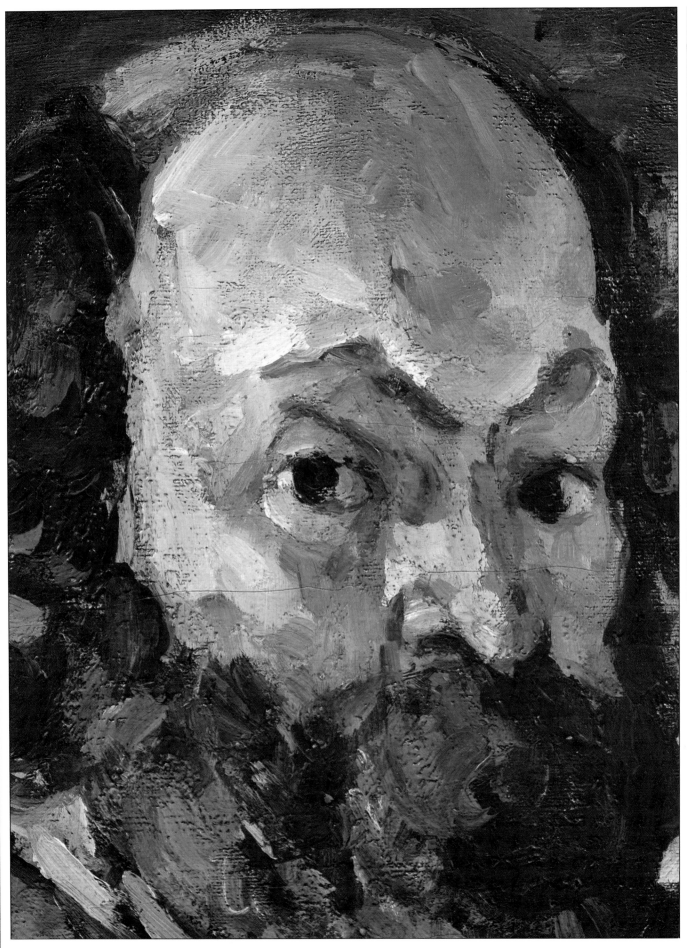

2 *Actual size detail*

THE HOUSE OF THE HANGED MAN

1873

21½×26in/55×66cm

Oil on canvas

Musée d'Orsay, Paris

When the first exhibition of the artists who were derisively nicknamed "Impressionists" took place in Paris in 1874, most of the major names we associate with that movement were represented. Cézanne was still regarded by some of the group as a rather difficult outsider, but he exhibited three canvases: *Landscape at Auvers, The House of the Hanged Man* and *A Modern Olympia.* The latter was a curious updating of Manet's famous picture of a nude prostitute, reminding us that the theme of eroticism and fantasy was never to disappear entirely from Cézanne's work. The two landscapes, however, mark the radical transformation of his art in the early years of the decade, and contain many of the elements that were to preoccupy him for the rest of his working life.

The House of the Hanged Man was painted at Auvers-sur-Oise, a village not far from Pontoise, and one of several locations that Cézanne had worked in with Camille Pissarro, his mentor at this period. The sinister title of the picture simply refers to the local name for the building, and has no immediate significance for the painting, though it is tempting to speculate that Cézanne, with his proven taste for the macabre, might have been initially attracted to it because of its name. At first sight, the painting represents a quiet, unpopulated corner of a rural village, neither picturesque nor squalid. There is no architecture of any distinction, such as a church or an imposing ruin, to focus our attention, nor are we encouraged to develop a narrative from the presence of figures or animals. The emphasis is on simplicity, immediacy and the understated poetry of an ordinary rural scene.

Such a scene might easily have become monotonous, but Cézanne has animated it through the subtle use of light, space and texture. Sunlight picks out the whitewashed houses and rough cart tracks, while plunging the thatched cottage at the right into contrasting shadow. Alternating areas of light and dark break up the picture surface, creating a series of blocks and triangles that exist in dynamic equilibrium with each other. Making maximum use of his hillside vantage point, Cézanne has cunningly overlapped the spatial planes of his picture to lead the viewer's eye both downward and further out into space. The rock-like object in the foreground partly covers the road, which leads steeply down to the house itself. Here our attention is picked up by the trees and jumbled roof tops, which in turn direct us to the distant hills and farmland. With remarkable sophistication, Cézanne has disentangled and given visual form to the spatial complexities of the scene, contrasting the blunt shapes of the foreground buildings with the airy lightness of a country landscape.

Many of the qualities of the painting acknowledge the lessons that Cézanne had learnt from Pissarro. It also shares with Pissarro's work and with that of many of the other exhibitors at the 1874 exhibition an acceptance of everyday subjects as fitting themes for painting — many of the conventional arbiters of taste at the time regarded such subjects as too mundane to be worthy of the serious artist's attention.

Cézanne's canvas shows all the signs of the struggle he had with his subject and with his medium. At this stage in his career he still worked with a loaded brush, and would paint over areas of the canvas that were already thickly worked. In some places, the resultant coarse, granular textures are appropriate to the rusticity of the scene, but in others the surface has become clogged. The thatched roof at the right, for example, is somewhat deadened by overpainting, and several areas of the picture show signs of cracking where the paint has been hastily built up. It is noticeable that Cézanne has used large brushes in most areas of the picture, almost eliminating fine lines and details.

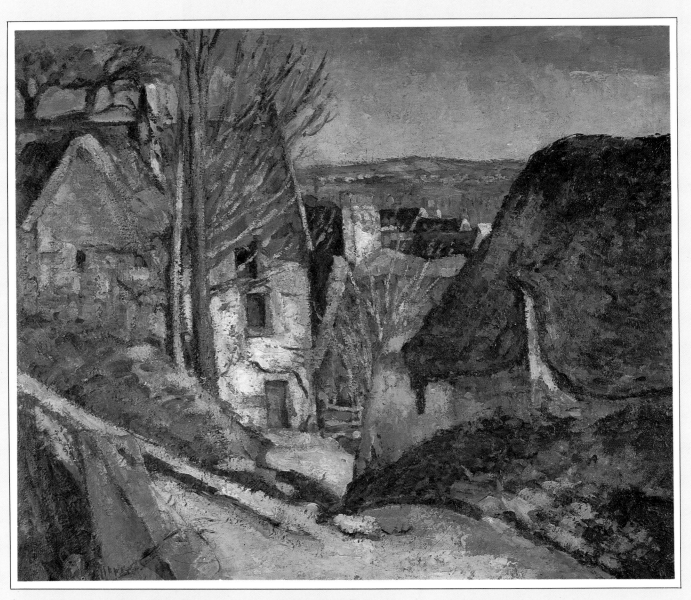

Almost certainly painted outdoors, though perhaps finished in a studio, the painting conveys something of the exhilaration that the shapes, colors and textures of nature produced in Cézanne. The composition, like so many of Cézanne's pictures in subsequent years, is established around a few boldly stated shapes and dominant lines. The sharp diagonal of the foreground cart track is balanced by the sloping roof of the right-hand cottage, while the pronounced verticals of trees and houses are complemented by the emphatic horizontal of the distant landscape. Characteristically, Cézanne softens the geometry of the picture with some well-placed foliage or a gentle curve, but the rigorous structure gives both strength and order to the complexity of his perceptions.

1

2

1 On a modest-sized canvas such as this, individual brushstrokes made with a large bristle brush can seem heavy handed, even crude. Only the vigorous flourishes of the paint and the rich textures of the surface prevent the picture from becoming inert. In this detail the steady build-up of paint can be seen, obscuring previous brushmarks and filling up the weave of the canvas surface.

2 Cézanne very rarely signed his pictures, and the presence of this signature, aggressively scribbled in red paint, is worthy of note. It was customary for artists to sign their works when they were about to be exhibited, and the inclusion of this painting in the 1874 Impressionist Exhibition may account for this exception to Cézanne's general rule. It may also imply, equally unusually, that Cézanne had both finished the picture and felt reasonably satisfied with it.

3 *Actual size detail* One of the delights of this picture is the way in which the process of painting has resulted in textures appropriate to the subject. The rough bark of the trees, the stained and weather-beaten surface of old whitewash and the lush vegetation of country roadsides all find new life in the scumbled and smeared paint. Heavily loaded brushes and perhaps a palette knife or even a fingertip were used to build up what is virtually a crust of pigment.

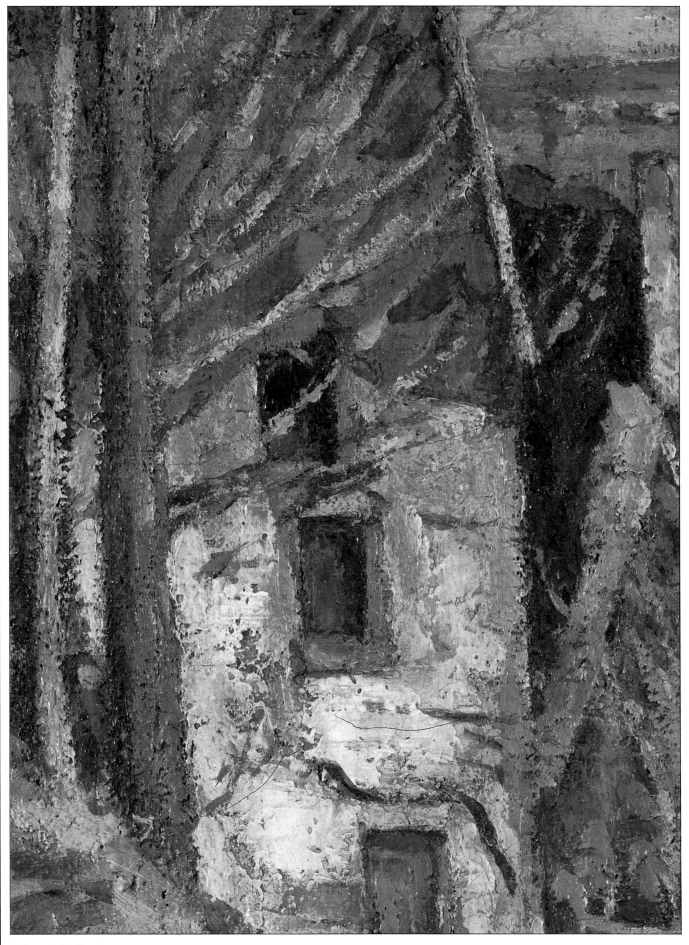

3 *Actual size detail*

The Etang des Soeurs at Osny

c1875

$23\tfrac{3}{4} \times 29$in$/60 \times 73.5$cm

Oil on canvas

Courtauld Institute Galleries, London

Studies of the fleeting effects of nature are surprisingly rare in Cézanne's work. At this period, Pissarro, Renoir and Monet all produced remarkable pictures of the landscape by painting rapidly outdoors on modest-sized canvases, developing an exceptionally acute eye for the nuances of shifting tones and colors. Cézanne, though he was entirely committed to working in the open air, directly in front of his "motif," could never fully reconcile himself to the spontaneous techniques of his colleagues. For him, painting was an almost insurmountably complex affair, requiring careful deliberation and endless revision, and he usually returned many times to the same site until he felt that he had fully "realized" the subject on his canvas. For this reason, some of his pictures became overworked and were hurled away or slashed in a fit of anger, but gradually he learnt to use thinner paint in the preliminary stages and thus avoid deadening the canvas surface.

Another unusual feature of the *Etang des Soeurs* is that it is executed almost entirely with the flat blade of the palette knife, rather than with paint brushes. Cézanne had used this implement, perhaps in imitation of the great Realist painter Gustave Courbet, in a number of pictures in the 1860s, but was to virtually abandon the technique soon after finishing this canvas. To use the palette knife effectively requires great skill, but it lends itself well to broad planes of color and to sensuously textured surfaces. Repeated reworkings with a knife, and with such thicknesses of paint, inevitably leads to clogging of the canvas and ultimately to severe cracking in the pigment layer, but it seems that Cézanne completed this small picture rapidly. Recent X-ray examinations have shown few variations between the first marks on the canvas and the finished image, and examples of wet paint applied over dry — such as the green strokes immediately to the right of the main tree trunk — are the exception rather than the rule.

If, in terms of its technique, this picture belongs to Cézanne's early years, its approach to the structuring and organization of nature points ahead to his maturity. Confronted by the tangled and chaotic appearance of natural vegetation, he has searched for the underlying rhythms. A strong horizontal thrust is established in the parallel lines of water and foreground path, and an equally urgent vertical movement in the trunks of the principal trees. Against this grid-like format, and to some extent softening its harshness, a gentle diagonal moves through the foliage from the top left to the lower right of the canvas. Within these broad currents, secondary eddies are established in the curve of a tree or the inflection of a branch, enough to particularize the scene without obscuring its essential momentum.

Cézanne's approach to nature was an intense and demanding one, deriving partly from his own feelings in the presence of the landscape and partly from his determination to make paintings that would be worthy of his sensations. In the *Etang des Soeurs* his delight can almost be sensed in the tremulous planes of green and gold applied with the knife, but his insistence on the fundamental organization of the perceived motif is equally apparent. While some areas of foliage may appear to have been slashed onto the canvas in sheer exuberance, other forms have been repeatedly adjusted with the palette-knife edge. The curving trunk in the foreground bends artfully upward and into the center, every inch of its contour sharply defined and redefined against its adjacent tone. Within the foliage, subsidiary branches and smaller trunks echo and mirror the curve of the dominant tree, reminding us that the organizing principle is at work even in Cézanne's most apparently spontaneous studies.

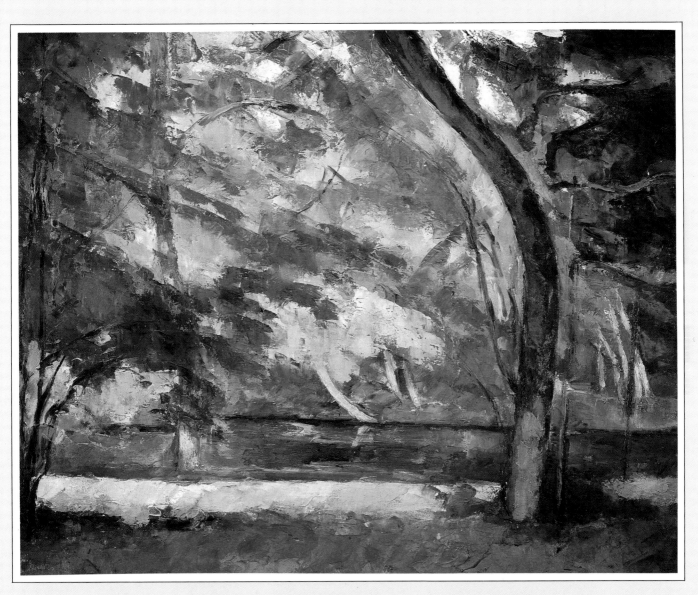

A shaft of sunshine, a brown-stained pond, some curving tree trunks and the lush foliage of summer are all the ingredients of this sparkling little painting. If it can be said to have a subject at all, it must be the limpid screen of sunlight that falls across the central plane of the picture, partly obscured by the silhouettes of foreground trees. It was painted at Osny, a village near Pontoise in the area where Cézanne worked extensively with Pissarro in the early 1870s. The connection with Pissarro is further strengthened by the fact that he once owned the canvas, probably as a gift from Cézanne or as part of an exchange with one of his own pictures. Pissarro also experimented with the use of the palette knife at this period, though both artists were to return to a more traditional brush technique soon after.

1

2

1 The buttery, semi-liquid nature of oil paint lends itself to dazzling effects in the hands of a skillful palette knife painter. Cézanne has used a cold gray for the sky, then superimposed layers of yellows and greens while the paint surface was still wet, adding a final flourish of warm brown to indicate the branch. Many of the individual strokes of the knife can still be clearly seen.

2 Paradoxically, Cézanne's passion for nature often led him to simplify organic forms in order to integrate them into the rhythms of his composition. Here the tree has become improbably tubular, and the surrounding branches echo its shape almost too perfectly. Most of the color has been applied with the blade of the palette knife, but finer branches were probably added with a brush.

3 *Actual size detail* The colors of the picture are dominated by a range of cool greens and yellows, subtly complemented by warmer hues in the pond and some of the trees. Black is freely used, both to deepen the green in the shadows and to strengthen dominant forms such as the horizontal line of the pond and the diagonal thrust of the foliage.

3 *Actual size detail*

THREE BATHERS

c1877
7½×8⅝in/19×22cm
Oil on canvas
Musée d'Orsay, Paris

It was one of the great ambitions of Cézanne's career to create large-scale compositions based on the nude. For centuries the nude had been regarded as the ultimate challenge for the artist, and the masters Cézanne most admired, such as Michelangelo, Veronese, Rubens and Poussin, were all supreme exponents of the European figure-painting tradition. Cézanne saw himself as part of this continuing tradition, and regularly visited the Louvre to study and copy the works of his predecessors.

The nude appears in his art from the beginning to the very end of his career. He put down hundreds of small studies of male and female figures in his sketchbooks, produced oil paintings varying in scale from the minute to the monumental, and devoted a number of watercolors and even lithographs to the subject. Hardly a year seems to have gone by when he did not develop a new variation on the theme and record his admiration for a painting or sculpture by another artist. But despite all these preparations, Cézanne's ambition to paint epic nude subjects was thwarted, and it was not until the end of his career that he embarked on a group of large-scale canvases appropriate to his vision (see page 13). By that time his health was failing, and the great *Bather* canvases were all left in states of partial completion, heroic fragments of a declining tradition.

The *Three Bathers,* an early and almost miniature example of his obsessive theme, forms part of a distinctive group of small-sized canvases devoted to open-air nudes from the decade of the 1870s. A small pencil drawing, lightly colored with watercolor and identical in almost every respect with the painting, was used to work out the composition of the figures, allowing Cézanne to proceed very directly with the oil painting. Virtually the whole picture surface appears to have been painted wet-in-wet, and there is every indication that the painting was executed at a single sitting, perhaps in a matter of hours.

The subject is both simple and highly complex. At an immediate level, we are presented with one of the most innocent and pleasurable of human occupations, bathing or idling beside a stretch of water in a country setting. One woman may be drying her foot, another rising to attend to her hair and a third squatting on the grass and stretching out her arms. The fact that we, as viewers, are implicitly invading the private space of these bathers seems relatively unimportant here, there being no apparent emphasis on the sexual or erotic possibilities of the scene. But as we look further at the picture, this initial, innocent interpretation begins to lose ground. It is noticeable that the two figures to the right appear to be scowling darkly, and the face of the woman on the left is just an intense streak of reddish-brown. The absence of any pictorially plausible stretch of water reopens the question of the "bathers'" activity, and their poses seem urgent, troubled. A sense of unease begins to pervade the picture, heightened by the alarmingly tilted tree on the left-hand side, and finally vindicated by the discovery of a brownish, mask-like male face amongst the foliage.

Reference to the preliminary drawing shows beyond doubt that Cézanne originally intended a fourth figure for this composition, an intrusive male, whose presence explicitly introduces the notion of voyeurism or even aggression into the tranquil scene. In Cézanne's work, sexual subjects are often shown as tense or violent, but here it is probable that a more specific allusion was intended. The archetypal theme of the beautiful woman discovered in her nakedness by a predatory man has surfaced in a number of guises in Western art, from Diana and Acteon to Susannah and the Elders, and here Cézanne appears to be rediscovering it.

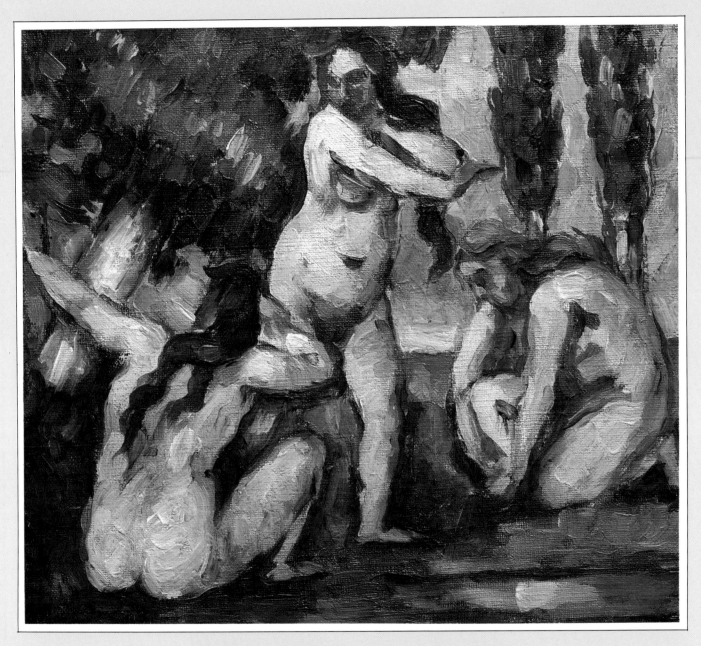

The canvas texture can be seen clearly throughout the picture surface, showing how lightly the paint was applied and how few second thoughts Cézanne had. The main forms of the painting were roughly "drawn" in using dilute dark-green paint and a small brush, after which thicker paint was applied in flickering, nervous touches. An exceptional liveliness and tension animates the picture surface, unprejudiced by a traditional sense of "finish."

1

2

1 Only the coarse flesh-color betrays the male presence amongst the trees. It might have even remained unnoticed had it not been indicated in the working drawing. The drawing shows an adolescent face, while in the painting it seems milder and more bucolic. Such overt references to voyeurism were to disappear in Cézanne's later nude studies.

2 The rhythmic, liquid quality of the brushstrokes is well illustrated in this detail; the woman's back and hair seem to flow or tremble in a single movement. The thin dark green paint of the original underdrawing can be clearly seen, as well as the improvised merging of one wet area of paint with another where later colors were applied.

3 The subject of nude women bathing was taken up by several of Cézanne's Impressionist contemporaries. Renoir, late in his life, was to paint a number of highly popular, idyllic scenes of plump girls on river banks, and Degas had already embarked on his extraordinary paintings and pastels of women washing or bathing. Degas owned one of Cézanne's small nudes, and was perhaps inspired by him to produce a group of outdoor bathing scenes in the 1890s.

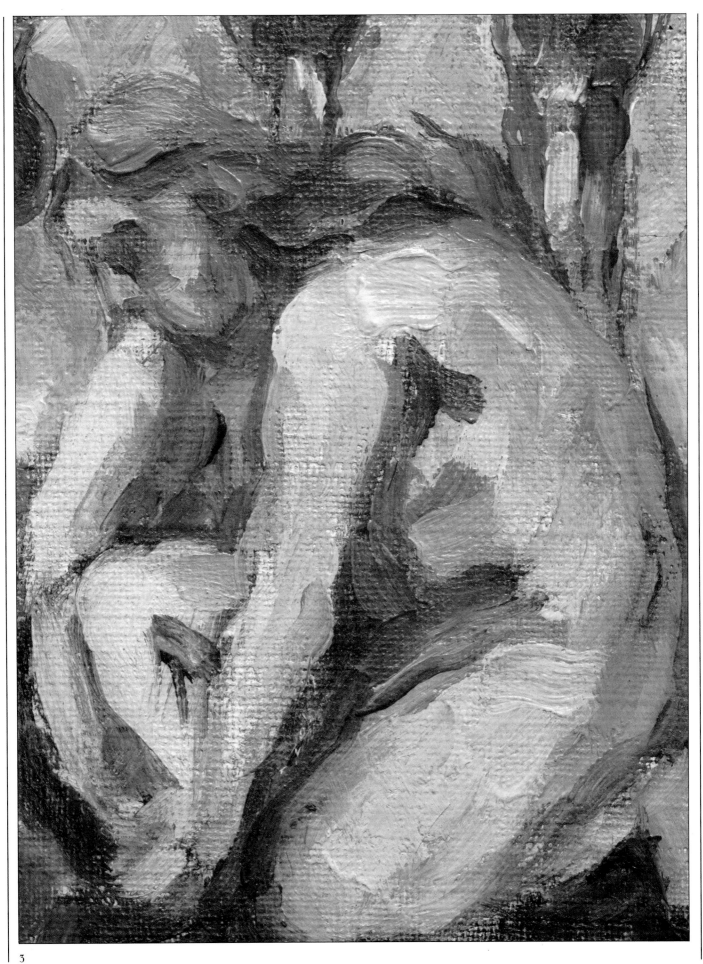

3

MOUNTAINS IN PROVENCE

c1885

21×28in/53×72cm

Oil on paper, mounted on canvas

National Museum of Wales, Cardiff

The Provençal landscape provided the subject matter for hundreds of Cézanne's paintings. The hot, dry weather of the region suited his way of working, changing little with the advancing seasons, and he noted that even the evergreen shrubs made painting easier by keeping their leaves throughout the year. But his attachment to the landscape was also a historical and emotional one. As a boy he had spent days wandering with his friends in the countryside around Aix, where they would fish, bathe and act out impossibly ambitious plays of their own devising. In later life he wrote nostalgically to his former companions, recalling their days beside the river. As he matured, Cézanne developed a fierce pride in his Provençal origins, stressing the importance of artists from the region, such as Granet and Puget, in his development and encouraging a revival of local literature among his young admirers. Every representation of Provence by Cézanne carries within it some of these associations, and there is always a suggestion of the grown man reliving the memories of a distant youth.

Mountains in Provence is neither large nor ambitious in subject, but it is a perfect summary of the preoccupations and achievements of Cézanne at the beginning of his maturity. The scene encapsulates the Provençal terrain, here looking back from the coastal region of L'Estaque towards the distinctively barren mountainsides of the area. In the middle distance there is a glimpse of water and some modest farm buildings; in the foreground the terraced slopes and stunted shrubs so typical of the Mediterranean landscape. Cézanne has chosen a scene without a central subject, allowing our eyes to wander from area to area within the picture. The line of foreground bushes establishes a sweeping incline that curves back to the block-like cabin, then is picked up again in the diagonals of the hillside. The blue of the water draws the eye back to the left of the painting, and finally the distant mountain swings us back and the circuit begins again. By means of a gentle zigzag from foreground to distance, the artist establishes the necessary space, while a circling movement keeps attention within the picture rectangle.

Cézanne's concern to give expression to the qualities of the landscape was always balanced by an equal concern for the language of the painting. The rhythms and relationships within his pictures came about after long scrutiny and the careful assessment of each tone, contour and color both in his subject and on the surface of his canvas. His aim was to create a unity within the picture in which each element had a clearly defined role and a specific relation to its surrounding elements. He once likened the workings of a picture to the intertwined fingers of two human hands, each locked securely into its neighbour and allowing no gaps or weaknesses to interrupt the pattern. In *Mountains in Provence* all the features of the composition can be seen in this way, every bush and every building taking its place in the overall harmony in such a way that their removal would destroy the equilibrium. While remaining true to his experience of the site, Cézanne has selected, manipulated and directed his observations into a pictorial network of forms that takes on a life of its own.

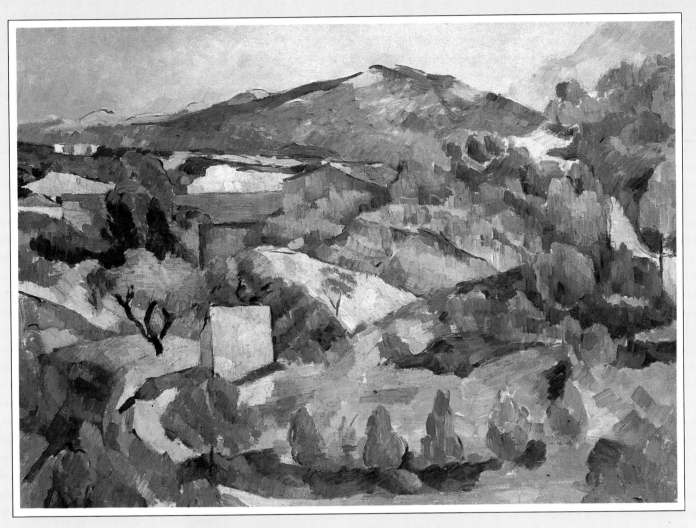

Prominent in this painting is Cézanne's use of the directional brushmark to emphasize the rhythms and structures of his composition. In the foreground, the ochers and whites of the soil follow the sweep of the rudimentary road, curving back as they flow between tree and cabin. In other areas, brushstrokes accentuate the curve of a hillside or the roundness of a bush, or simply assert themselves as flat planes on the surface of the canvas. Unusually for Cézanne, the picture was painted on a commercially prepared paper rather than on canvas. Such papers were available, then as now, from artists' suppliers and were generally associated with rapid outdoor sketching rather than with finished paintings. All the evidence suggests that this scene was executed by Cézanne in the open air in front of the subject, the prepared paper pinned to a board on his easel and the oil-colors applied quite thickly from his palette. The paper was laid down onto canvas at a later date.

1

1 The directional, or constructive, brushmarks can here be seen building up the embankment beside the road as well as drawing the viewer's attention away from the corner and back into the picture. The paint is applied quite thickly, and some superimposition over previous colors can be clearly seen, a practice that has led to cracking in some parts of the paint surface.

2 Parallel strokes of several colors, applied while the paint was still wet, are allowed to merge in this central area. Unlike most of the surrounding hillside, this terrace is cooled down with touches of pale blue, perhaps added as an afterthought by the artist to introduce contrast into the hillside.

3 *Actual size detail* The bright sunlight in this scene creates a number of brilliant highlights and saturates the natural colors of earth and foliage. Cézanne is selective in his depiction of shadows, accentuating that of the cabin wall but omitting that of the tree altogether. The intense blue of the distant water animates the middle distance while acting as the perfect foil for the browns and ochers of the foreground.

2

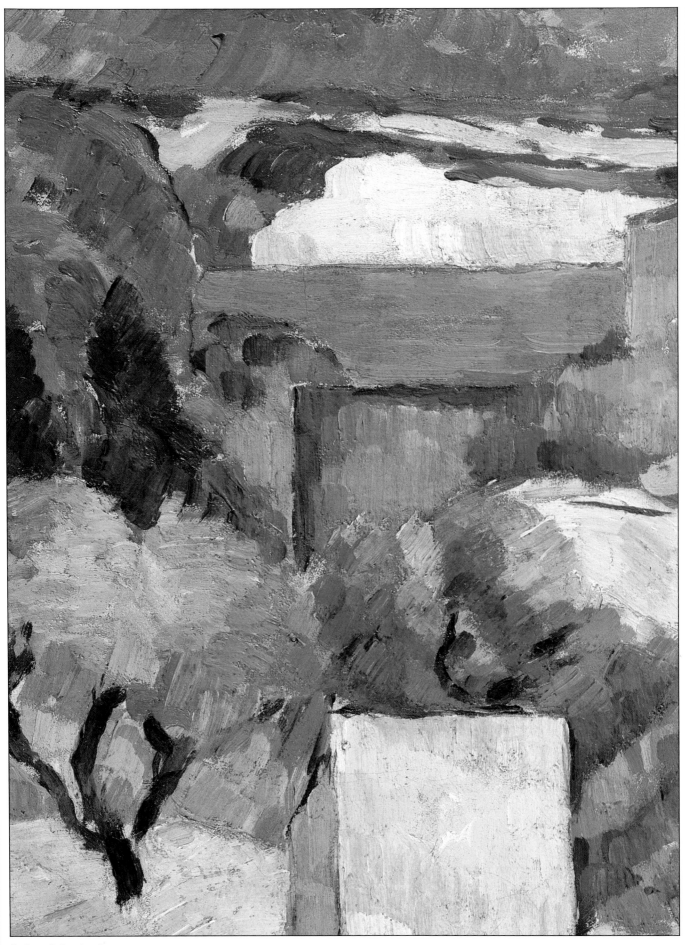

3 *Actual size detail*

POT OF FLOWERS AND FRUIT

c1888-90

18⅛×22in/46×56cm

Oil on canvas

Courtauld Institute Galleries, London

Still life had a special importance for Cézanne, more so than for any of his Impressionist contemporaries. Traditionally, still life had been regarded as an inferior category of painting, unequal to the morally elevating historical scene or the psychologically profound portrait. Some artists, such as the 18th-century French painter Chardin, had become famous principally for their still lifes, but generally the subject was left to obscure specialists or to the occasional demonstration of skill by masters better known for their other work. At least two of the 19th-century artists whom Cézanne admired, Delacroix and Courbet, had produced ambitious and original still lifes, but Cézanne could claim to be the first major artist to have raised the *genre* to the same level as his portraits, nudes and landscapes. In the course of his career he produced several hundred examples, principally in watercolor or oils, and he single-handedly promoted a neglected subject into a major medium of artistic expression.

The reasons for Cézanne's near-reverence for the still life were complex, but principal amongst them was its potential for order. With any other subject, from landscape to the human face, the artist is in the hands of nature and must edit or modify the forms that are presented to his eyes. When arranging a still life, these rules are reversed: shapes can be added, lighting changed at will, even colors altered to suit the demands of the composition. We know from contemporary accounts that Cézanne took full advantage of this God-like power over nature, painstakingly adjusting the positions of the humblest object and propping plates or jugs up to the required angle with piles of coins. It is also known that he amassed a large miscellaneous collection of household utensils, such as coffeepots, sugar bowls and a variety of jugs, to provide him with precisely the right contour or touch of color in a particular configuration. Certain objects, like the famous blue ginger-jar or the plaster cast of Cupid, recur in a number of different pictures, and others, most conspicuously a dark green olive pot, must have been painted scores of times.

Having established the arrangements of objects to his fastidious satisfaction, Cézanne was then able to exploit the other great advantage of the still life, its relative permanence. Unaffected by the vagaries of weather, free from the demands of a human subject, the group of apples or the arrangement of crockery becomes the perfect model. Unchanged from day to day, impassive and self-effacing, it was the ideal subject for an artist who worked slowly and needed to return to precisely the same disposition of forms and tones day after day, even week after week. For Cézanne, with his meticulous, intensely self-critical approach to painting, the dense web of visual relationships to be found in a group of ordinary household objects was equal to the challenge of a landscape or a human figure.

Paintings such as *Pot of Flowers and Fruit* have an extraordinary intensity which only comes from hundreds of hours spent in direct engagement with the subject. Simple though the objects are, every nuance of tone and every inflection of hue has been scrutinized, and every interval and relationship between adjacent objects tested. No leaf is the same color or has quite the same character as another leaf, no square inch of table-surface is unquestioningly tinted with the same tone as its neighbour. Contours and boundaries of objects have been crisply defined and as often redefined, marking the progress of the painting in a sequence of colored halos or reverberations. While the identities of the modest plant and its attendant fruit are vividly characterized, the spectator is everywhere conscious of the functioning of the artist's perception.

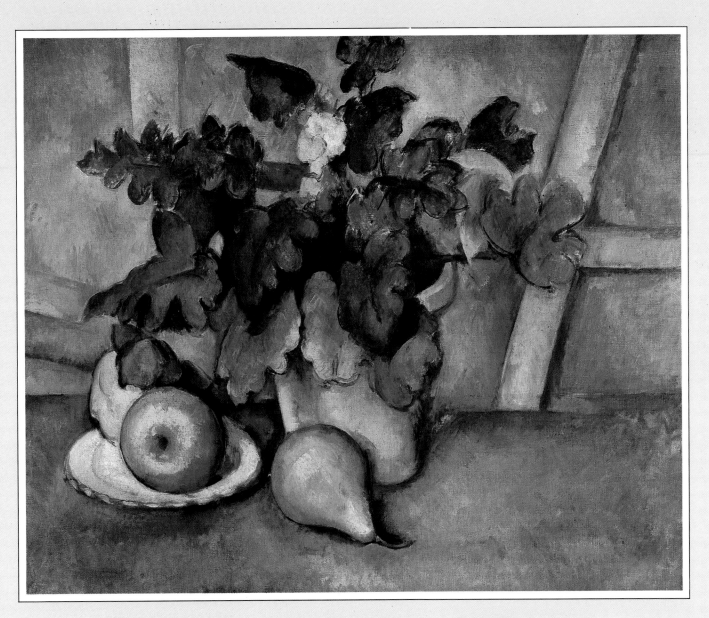

Cézanne's delight in nature extended to the simplest fruit or vegetable, and the forms and colors of this picture bear witness to this delight in the most emphatic way. We are offered both underside and profile view of the almost-too-perfect pear, and the ellipses of plate and plant pot suggest multiple viewpoints within a single object. Even the table top, conventionally expected to run straight across the picture, is broken into a series of steps as if to respond to three varying perceptions. By the middle of his career, Cézanne was using paint with considerable discipline, building the picture from thin washes as he established his initial composition, to more opaque strokes of paint in the last highlights. In this picture, the original "drawing" of the forms with a fine brush can be seen — the artist favored a deep blue for this operation. Some areas of color, such as the grays of the table top, were then brushed in with thinned paint, while the objects themselves were worked more solidly.

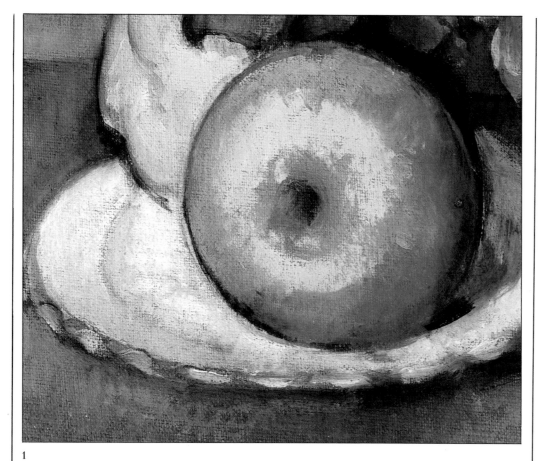

1

1 Cézanne included pears or apples in hundreds of his still life pictures, perhaps because of their easy availability and rich coloring but also conceivably for their symbolic overtones. Here the fruit is an ideal specimen, unblemished and arranged to conform as nearly as possible to a perfect sphere. Skillfully manipulating the density of his colors, Cézanne fills out the roundness of the form and stresses its autumnal ripeness.

2 In this small area of apparently neutral foreground, it is possible to identify browns, purples, greens and blues. Even though they are tonally very close, their combined effect is to bring an unexpected intensity into what might otherwise have been a lifeless stretch of gray.

2

3 *Actual size detail* Color is given unparalleled license in some of Cézanne's still lifes, and here touches of virtually every primary and secondary hue are visible within inches of each other. The shadows on the plant pot include blues, greens, red-browns and pinks, while the pear runs through the spectrum from red through yellow to green. Touches of black are still in use to strengthen a curve or subdue a wayward tint, but it is color that effectively describes the forms.

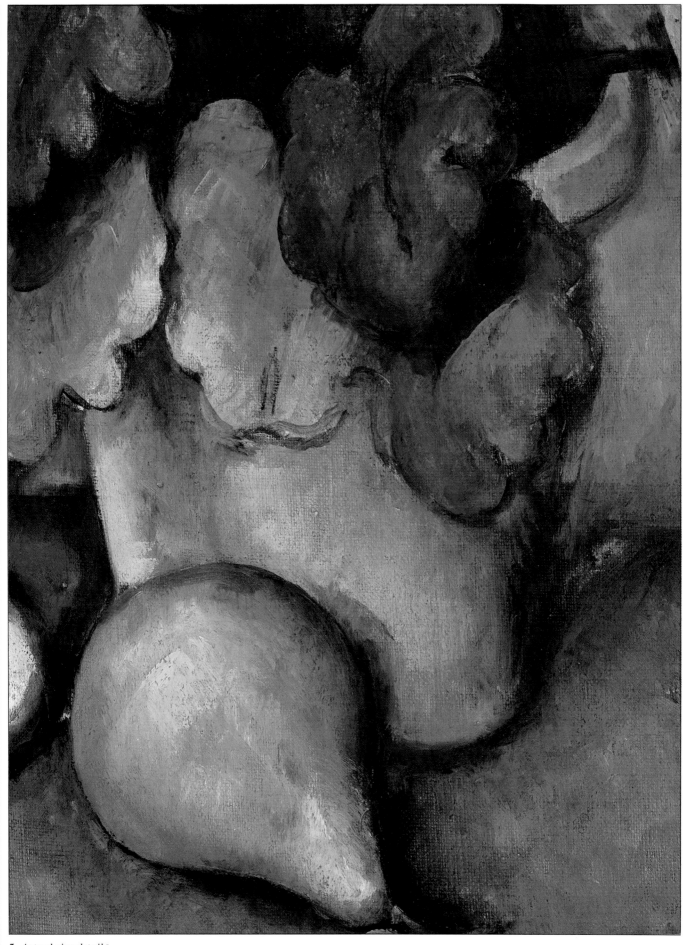

3 *Actual size detail*

MONT SAINTE-VICTOIRE

c1902-6

14¼×21¾in/36×55cm

Watercolour

Tate Gallery, London

This mountain at the heart of Provence, dominating Cézanne's birth place at Aix, acquired an almost mystical significance for him in his later years. It first appears in the distant background of certain early pictures, and then recurs repeatedly until the final months of his life, developing from a remote landscape feature into a central motif. Just as Monet returned time after time to his water-lilies and the aging Degas to his dancers, Cézanne seems always to have found fresh possibilities and inspiration in this mountain, which was both subject matter and private obsession.

In the later part of his career, Cézanne turned more and more towards watercolor. Although he also did watercolors in his early years, these tended to be small studies related to more ambitious oil paintings; it was not until his maturity that he used watercolor as a medium in its own right. For an artist of Cézanne's habits and temperament, it had a number of advantages. It is easily portable and can be carried on walks into the landscape, often without the need for an easel and other cumbersome equipment. Being water-based, it is extremely quick-drying, especially in the warm air of the Mediterranean where successive strokes of the brush will dry as soon as they are put down. Given Cézanne's insistence on working outdoors and his need to paint and re-paint certain areas of his picture, it is not surprising that many of his most remarkable late landscapes were executed in this medium.

Mont Sainte-Victoire, painted in the last years of his life, is an example of Cézanne's fully developed watercolor technique. The whiteness of the paper was used to establish the tone of the picture, and then systematically inflected and modified by fine touches of dilute color. Initially, a light pencil drawing indicated the broad outlines of the composition, followed by pale washes of paint as areas of tone or color were identified. As soon as the first marks appeared, the painting took on a rudimentary existence, and relationships between one form and another began to grow. Cooler colors, such as blues, tend to recede, suggesting depth, while the warmer reds and ochers advance toward the picture plane. Here the blues of the mountain locate it firmly in the distance, while touches of other colors are introduced to maintain the overall harmony of the picture. Nearer to the viewer, the denser web of yellows, greens, purples and browns gives substance to the foliage, but again touches of blue are used to link this area with the distant mountain.

As the painting progressed, further washes of color were laid over those already dry, suppressing an over-warm hue or giving greater weight to an area of shadow. In places, this superimposition of veils of color has been repeated as many as ten times, and it is possible to glimpse pale reds, greens, blues and yellows within the same block of tone. Every touch of color represented for Cézanne another moment of perception, another observed nuance in the scene which must be translated into the language of his picture. Modifying, adjusting and refining his image, Cézanne advanced in a series of infinitely patient steps towards that unified and harmonious representation of nature that he had pursued for more than thirty years. Looking at his mountain once again, he added another pale thread of blue watercolor to the half-dozen already on its flank, endlessly re-defining the shape he must have known as intimately as anything he painted.

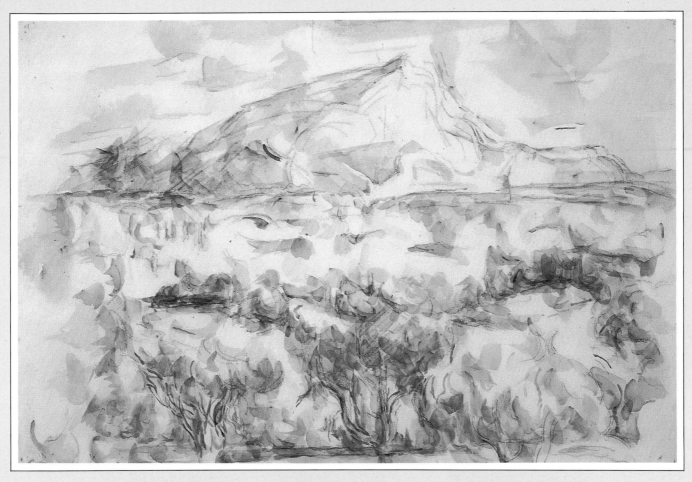

The composition of *Mont Sainte-Victoire* is both simple and dramatic. By lifting the horizon into the top half of the picture and moving close to his subject, Cézanne has largely eliminated the sky and allowed the mountain to dominate the scene. None of the usual perspective devices, such as receding roads or angled buildings, are allowed to clutter up the middle ground, and space is principally evoked by the relative intensities of colors and tones. Mont Sainte-Victoire is a surprisingly dramatic mountain, a bulging grey eruption of rock some five miles to the east of Aix, which can be seen from great distances across the much flatter surrounding countryside. To the north it curves fulsomely down towards its lower slopes, while in the south a cliff-like face interrupts the symmetry. Cézanne painted the dramatic mountain from many angles and vantage points, sometimes merging its contours into the lines of a landscape and sometimes moving in closer toward the awesome bulk of the rock. As if to test himself against a fixed point, he depicted it at every season, on every scale and in all the media he had at his disposal.

1

2

1 Much of the energy in this painting comes from the wide variety of brushmarks that Cézanne employed, from rectangular blocks of pale color in the earlier stages to nervous, flickering strokes of greens and yellows in the foliage. The broader marks would be achieved with the side of the brush, the fine blue lines with the tip, while some of the final touches appear to have been almost jabbed onto the paper.

2 Cézanne's technique of superimposing thin veils of color can clearly be seen in this detail, where a number of brushstrokes have been applied in several different directions on the same area of paper. The delicacy and animation of the successive paint layers prevents the surface of the painting from becoming deadened, while the varied angles of the brushmarks suggest dynamic forces at work in both the landscape and the picture.

3 *Actual size detail* In many of Cézanne's paintings, the shapes of the subject are either chosen or modified in order to "rhyme" with each other. A piece of fruit may echo the shape of a dish or jug, or in this case the mountain is reflected in the forms of the landscape beneath it. Cézanne has artfully emphasized a plunging curve in the foreground foliage, matching the curve of the mountain and giving greater unity and resonance to the picture.

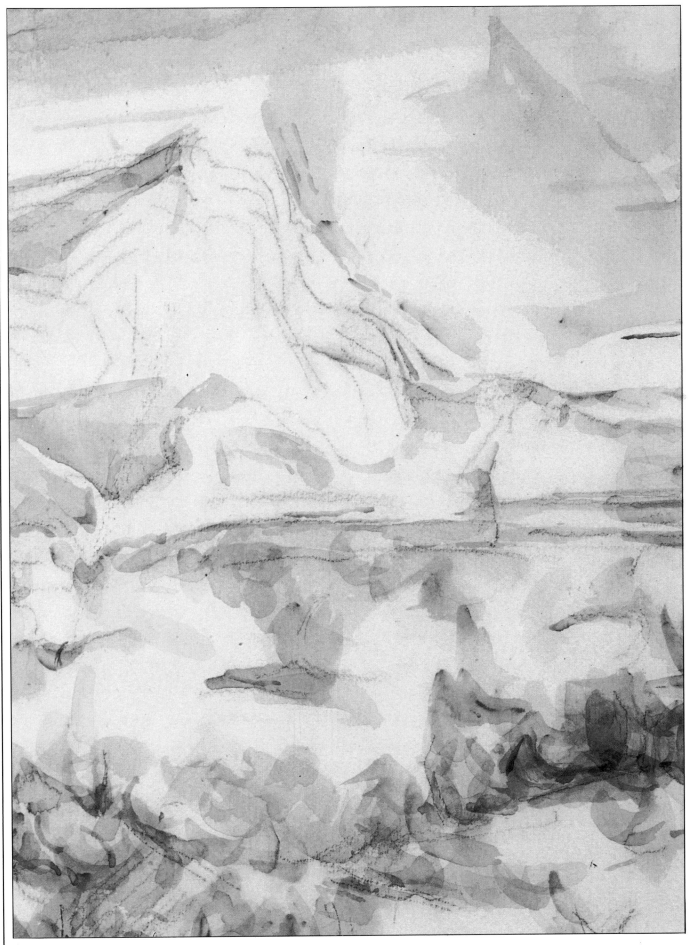

3 *Actual size detail*

WOMAN WITH A COFFEEPOT

1890-95

51¼×38¼in/130×97cm

Oil on canvas

Musée d'Orsay, Paris

The identity of the sitter in this monumental late portrait has never been discovered, the best conjecture being that she was a servant or neighbor at Cézanne's family home, the Jas de Bouffan. The patterned wallpaper and paneled doors indicate a house of some pretension, and the presence of the coffeepot suggests a social call or some moment of leisure. Everything about the woman herself, on the other hand, points to a domestic function, from the heavily accentuated hands to the plain dress and severe hairstyle, and even her apparent awkwardness as she sits on an unseen chair.

Portraiture played a constant and central role in Cézanne's art. His first models were his family, painted in the then recently acquired Jas de Bouffan and surrounded by similarly patterned wallpaper and plain furnishings. In subsequent years, he painted many of his friends, his mistress Hortense and their son Paul and a number of self-portraits. Few, if any, of his portraits were undertaken as commissions; Cézanne's motivations for portraiture must be looked for elsewhere, either in a reverence for past traditions or in his sense of the portrait as the ultimate challenge for the artist.

Cézanne was a most demanding portraitist, and a number of his other subjects have left accounts of their sittings. Always a slow and painstaking worker, Cézanne approached his portraits with a special seriousness and expected absolute concentration and cooperation from his model. One of his subjects, the art dealer Ambroise Vollard, describes how the slightest noise or the smallest movement would upset the painter, who expected him to sit as still as one of his still lifes of apples. Outbursts of anger would follow an unsatisfactory session, followed by threats to destroy the painting if certain relationships on the canvas could not be resolved.

Woman with a Coffeepot is clearly the product of a similarly epic process of concentration and labor, though there is every reason to believe that it was considered complete. A large canvas, every part of it has been densely worked, with heavy encrustations of paint in places. Certain features, such as the head and the still life group, might be expected to receive this kind of attention, but even relatively neutral areas like the paneling and wallpaper have been intensively repainted as the picture progressed. As in so many of Cézanne's pictures, every element has been scrutinized and continually reassessed, leading to a series of subtle modifications of color and form or to slight shifts of emphasis within the picture.

Though apparently straightforward in composition, a careful examination of the picture reveals a sophisticated series of pictorial relationships which have been finalized only after much deliberation. A pose which is largely symmetrical challenges the artist to exploit variety and incident where he can discover it. The woman's left arm, therefore, is contrived to appear dark against a light background, while her right arm is bright blue in an area of shadow. Similarly, her head stands out against the dark paneling on one side and coincides with a lighter passage on the other, throwing it into the greatest possible relief. Other asymmetries, such as the paler hand set opposite the darker, are seized upon, and all of them echoed in the audacious balancing of a coffee table on the right-hand side of the picture with a strip of ornament on the left. Continuing his bold manipulations, Cézanne has rearranged the perspective of a number of features within the painting, presenting the woman's torso from the front while her lap is seen from above. Similarly, the cup and the table top suggest a high vantage point and the coffeepot a frontal one, as if the artist is incorporating several different experiences of the scene into a single painted image.

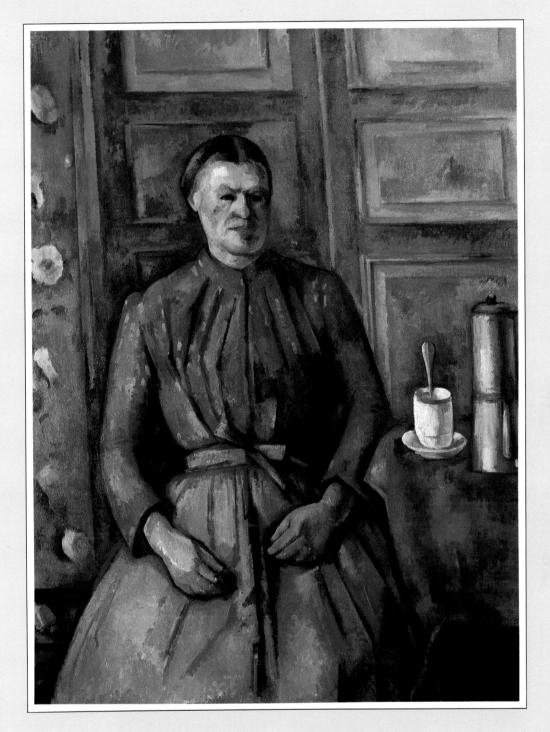

The compositional structure of this painting is spelled out with unusual clarity. In the background, the horizontal and vertical divisions of the wooden paneling establish a severe grid, which is repeated elsewhere in the tall cylinder of the coffeepot and some of the lines of the woman's dress. Against this grid, the contours of the figure, the rounded shapes of head and hands, and the ellipses of cup and saucer take on a contrasting fullness. Characteristically, Cézanne does not allow any of these forms to become rigid or lifeless: each vertical tilts slightly, and each curve has its imperfection.

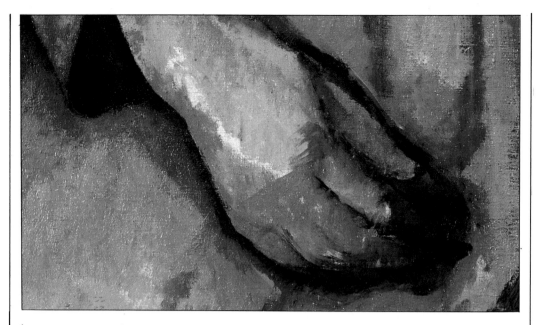

1

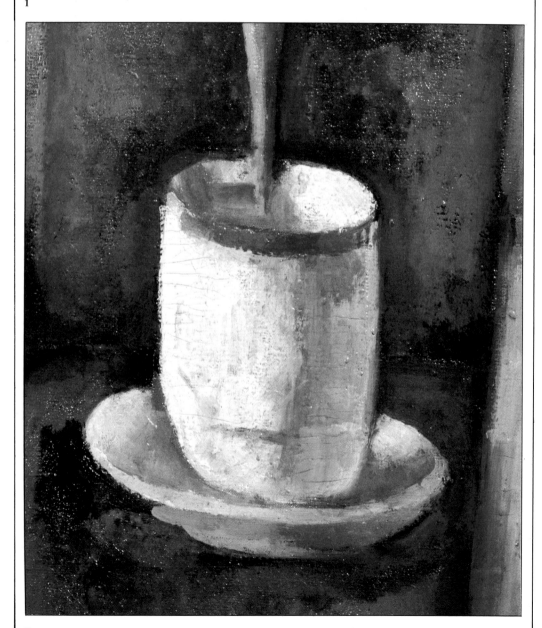

2

1 The expressive prominence of the woman's hands is reminiscent of a number of portraits of women by Rembrandt, an artist much admired by Cézanne. Here, the dark halo of paint around the contours of the hand works to define its shape, but also thrusts it forward into space, accentuating the warmth of the flesh against the blue of the dress.

2 The license that Cézanne gave himself in the depiction of objects is well demonstrated in the willful asymmetry of both cup and saucer. The curves at the left and right sides of the cup do not match, and the edges of the saucer cannot be made to meet if they are continued behind the cup. The result is fresh and invigorating, and quite distinct from mere imitation.

3 *Actual size detail* Most of Cézanne's portraits show members of his own family or ordinary people from the Aix area. At about the time of this picture, he also produced several studies of local men playing cards, and embarked on a series of paintings of his gardener, Vallier. Here he draws attention to the heavy features and unrefined demeanor of this working woman, the fullness of her face established in coarse blocks of boldly applied color.

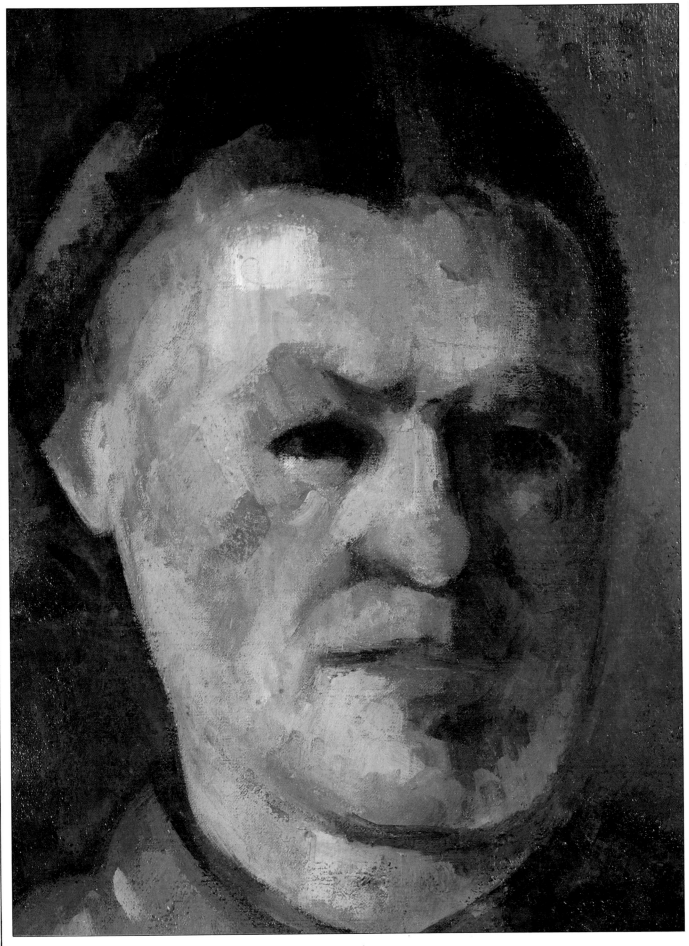

3 *Actual size detail*

STILL LIFE WITH ONIONS

1895-1900
26×32¾in/66×82cm
Oil on canvas
Musée d'Orsay, Paris

In the last decade of his life, the pattern of Cézanne's artistic activity became settled to the point of routine. The turbulent years of conflict with his family and the hostile reception of his publicly exhibited work were behind him, and his financial difficulties had been resolved by the death of his father. Basing himself increasingly at Aix, he was now able to devote himself to the business of painting, working in his studio or outdoors in the countryside he had known since childhood. As part of the settlement of his father's estate, the family home, the Jas de Bouffan, was sold, and Cézanne worked for a while in a studio near the town center, but in 1901 he arranged for a new studio to be built just to the north of the town, within sight of Mont Sainte-Victoire. Here he was free to pose his models, set up his still life groups and tackle some of the largest and most ambitious canvases of his career.

More precisely than at any time in his earlier life, Cézanne's late work falls into four distinct categories: the nude, the portrait, the landscape and the still life. Profoundly traditional in many of his attitudes, Cézanne had brought all these themes into a local and contemporary context while disregarding the visual evidence of the industrial age in which he lived. While his contemporaries such as Monet and Degas had tackled the urban experience of modern Paris, Cézanne remained true to his country origins, cursing the introduction of modern street lighting and mocking the improvements of the "engineers." Though he made frequent use of the train system in his journeys to and from the capital, his art made few concessions to the structures and sensations of a technological society.

After his death, Cézanne's new studio at Aix was kept intact, and much of the furniture and many of the still life objects that he preferred to paint can be seen there today.

Amongst them is the simple wooden table with a curving lower edge that features in *Still Life with Onions,* providing a rare opportunity to compare an object with its painted counterpart. In the painting, the table front is faithfully recorded, but a glance at its side reveals the kind of radical departure from verisimilitude for which Cézanne became famous. While the table's side face points sharply upwards, creating a tilted plane that would only with difficulty sustain the group of objects on it, the ornamental edge creates a deep curve that cannot be made to correspond with the pattern visible at the front. Rather than lose that curved side in a pedantically correct rendering of perspective, Cézanne has openly flouted the conventions of representation and created a rhythmic element in tune with his painting. As his contemporary Degas said, "We create the true by means of the false."

The objects on the table top come from Cézanne's standard repertoire — similar plates, bottles, knives and fabrics recurring in a dozen other paintings, though here the more familiar apples and pears are supplanted by a group of onions. The fruit and vegetables he chose for his still lifes are always the ordinary products of local kitchen gardens, and sometimes include melons, eggplants, pomegranates, lemons and oranges. It is difficult not to see the artist's elevation of such modest objects into the realms of art as some kind of celebration of the rustic, and here his sumptuous delight in the silvery-pinks, reds and terracottas of the onion skins is evident. Given the slowness with which Cézanne worked, it is also tempting to imagine that the onions with which he started have visibly sprouted, or in some cases withered, in the process of painting. It is known that he had recourse to wax fruit and paper flowers when his natural specimens faded.

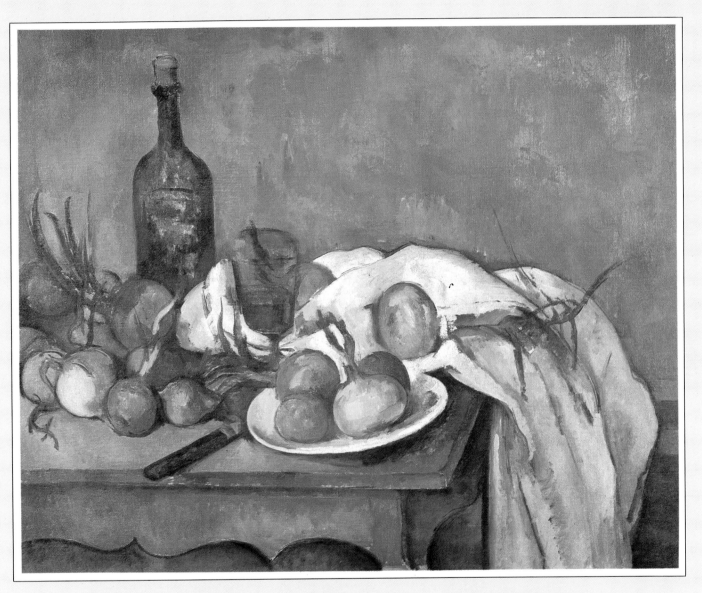

The composition is notable for its asymmetry, the daringly off-center table balanced by a cascade of white cloth at the opposite side of the picture. At the left, a wine bottle provides a necessary vertical accent, though its surface qualities are suppressed to avoid over-weighting that already crowded area. The fragile equilibrium of the painting turns around the central white plate, with its strongly individualized onions. Here Cézanne has invested each form with all the roundness and gravity that his considerable resources could conjure up, setting off the hard shallowness of the plate against the plump, organic shapes of the onions themselves. The painting makes exemplary use of the warm and cold properties of colors, contrasting the rich red-browns of the table and onions with the cooler, receding blues and greens of the background. By setting the central group of onions against the whiteness of both plate and cloth, Cézanne has accentuated their density of color and tone.

1

1 The canvas weave is visible throughout the picture, showing that Cézanne used thin paint to begin with and touched in the main colors lightly. In this detail a last-minute revision of the painting is visible where he has added white paint over a previously indicated leaf, perhaps responding to the changing position of the leaves as the picture progressed.

2 The fine, darker strokes show where the table was originally drawn in with a brush and where Cézanne has subsequently modified its outlines. This blatant disregard for traditional perspective is justified by the rhythms and curves of the composition, not by any structural peculiarities in the carpentry.

3 *Actual size detail* The variation within the paint surface shows how Cézanne has laid down the thin area of shadow beneath the plate, then worked up to relatively dense impasto in the areas of greatest prominence, such as the rim of the plate and the highlights on the onions. The paint handling is highly disciplined, but is not without its moments of improvisation.

2

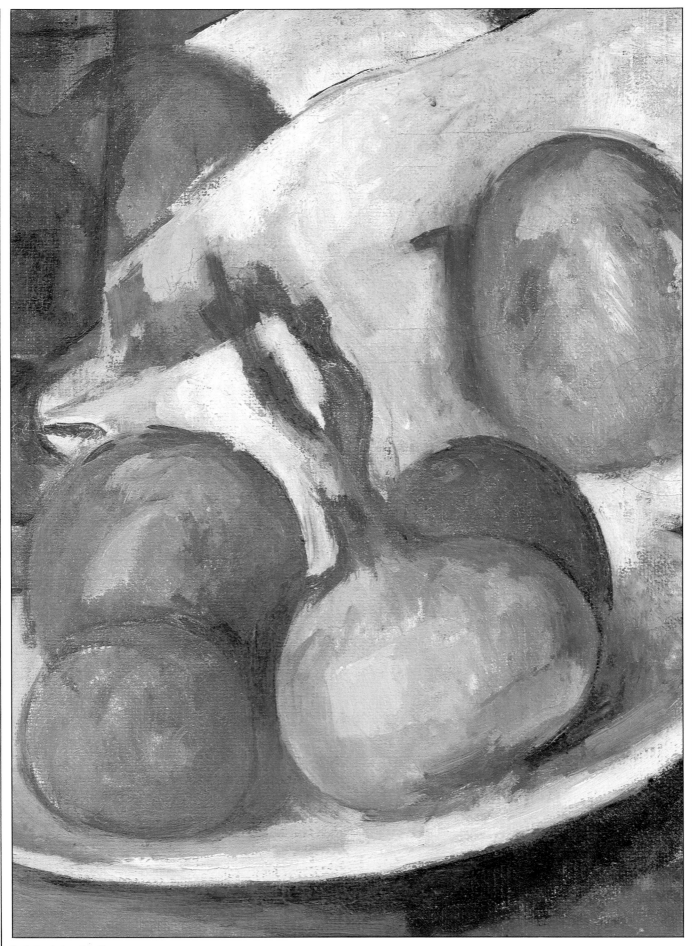

3 *Actual size detail*

THE RED ROCK

c1897
25½×31½in/65×80cm
Oil on canvas
Musée de l'Orangerie, Paris

One of the local sites most associated with Cézanne's last years is Bibémus quarry, situated a little way out of the town of Aix-en-Provence in the direction of Mont Sainte-Victoire. The quarry had been dug into a wooded ridge within sight of the mountain and used as a source of stone for the buildings in Aix in earlier times, but was already overgrown by trees and shrubs in Cézanne's day. At Bibémus, Cézanne could work alone and undisturbed within walking distance of his studio, and he was able to produce a large series of drawings, watercolors and oil paintings of its red-brown rocks and wild vegetation.

Cézanne's inclination towards strongly stated forms and grid-like structures in his paintings seems to have found a natural subject at Bibémus, where the sharply cut verticals and diagonals of the rock-faces impose a sense of order on the surrounding vegetation. Many of his Bibémus paintings exploit the opposition between the block-like rocks and the more organic curves of bushes and trees, and in *The Red Rock* we find one of the most startling of these confrontations. In the distance, the quarry workings have become choked with greenery and only glimpses of rock can be seen, but in the foreground a vast ocher-red slab of cut stone looms into the picture. Much of the rock at Bibémus was cut at an angle, so that the abandoned faces appear to lean outward in this way, and a number of similar features still survive in the quarry today.

This brilliant red intrusion into the painting challenges both the symmetry and the integrity of the composition. Much of Cézanne's handling of the rest of the picture, such as the arrangement of the foliage and the balance of colors, can be seen as an attempt to accommodate the red rock within a more general harmony. The strong red-brown of the foreground, for example, as well as the touches of the same color in the trees and even sky, help establish continuity with the rock, while certain lines among the trees echo its triangular shape. Cézanne's delight in the underlying rhythms of nature is clearly demonstrated in the curving, wave-like pattern of the foliage, and again the rounded forms that emerge, such as the spherical bush at lower left, seem designed to complement the angular rock. Such a flat, uncompromising and geometric intervention into a landscape strains the capacities of the medium, but it is difficult to imagine any other artist either taking on the challenge or coming so close to its resolution.

Cézanne's ideas about painting were never systematically written down and have been the cause of much subsequent debate. Many letters to his friends and family survive, though he had a marked aversion to theoretical discussion and tended to refer to the mundane and the domestic. At about the time he was working on *The Red Rock,* however, he had attracted the attention of a group of young artists and writers, and his correspondence with them contains a number of remarks about art that have subsequently become much quoted. Writing to the painter Charles Camoin, Cézanne advised him "You do well above all to study from nature," and admitted that "The understanding of the model and its realization is sometimes very slow in coming for the artist." To another admirer, Emile Bernard, Cézanne insisted that "One must look at the model and feel very exactly, and also express oneself distinctly and with force," and (only a year before his death), "we must render the image of what we see, forgetting everything that existed before us."

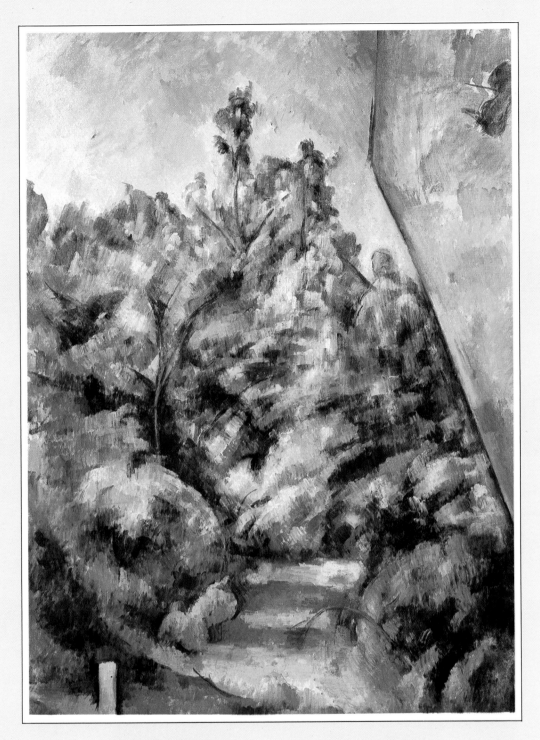

The redness of the rock is as shocking today as when Cézanne conceived the painting. The brightness of the Provencal sunlight conspires with the intense natural pigment of the local stone to produce a rich reddish-ocher hue which can still be seen in some of the stone-built houses of Aix-en-Provence. Such warmth of color also thrusts the rock face to the front of the picture, in contrast to the receding greens and the cool blue of the sky. This interplay between the surface qualities of color and brushwork on the one hand with the naturally recessive tendencies of landscape elements on the other is a constant theme of Cézanne's late painting.

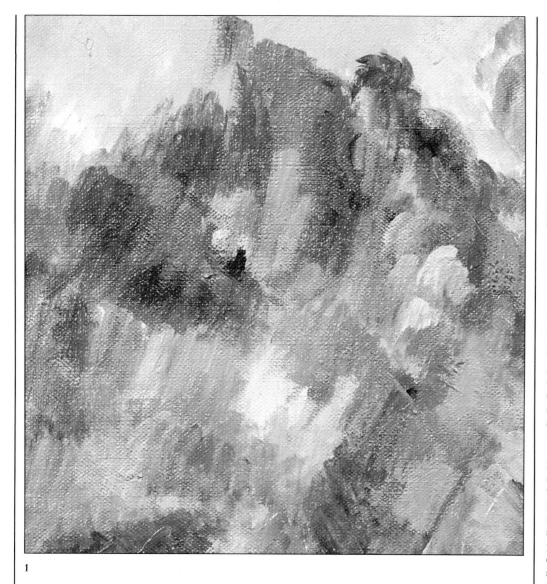

1

2

1 Cézanne used greens with great confidence in his pictures, often preferring the sharp acid tints of emerald and chrome green or the heavier hues derived from viridian. Here the mixture of greens with touches of the earth-browns of the Bibémus quarry produces a broad spectrum of contrasting hues, suggesting the lushness of the wild vegetation.

2 Despite the picture's title and the apparent brightness of the rock, the "red" is largely made up of natural earth pigments, such as burnt sienna and yellow ocher. The paint is brushed onto the canvas with an abandon that seems almost careless, though the careful redefinition of the edge of the rock emphasizes its importance in the picture.

3 *Actual size detail* The masterly skill Cézanne had achieved in his old age can be seen in the way he tackles this largely featureless area of foliage and transforms it into a vibrant series of colors and forms, each of which resonates within the general harmony of the picture. The identity of path and bushes is firmly insisted upon, but their integration into a larger whole is equally pronounced.

3 *Actual size detail*

Index

Acknowledgements

64

PHOTOGRAPHIC CREDITS
Burrell Collection, Glasgow 11; Courtauld Institute Galleries, London
31-33, 43-35; Hubert Josse, Paris 6, 9 bottom, 10, 19-21, 23-25, 27-29,
35-37, 51-53, 55-57, 59-61; Museum of Fine Arts, Boston 9 top;
National Gallery, London 7, 12, 13; National Museum of Wales, Cardiff
39-41; Tate Gallery, London 47-49.